IMAGES
of America

DANA POINT

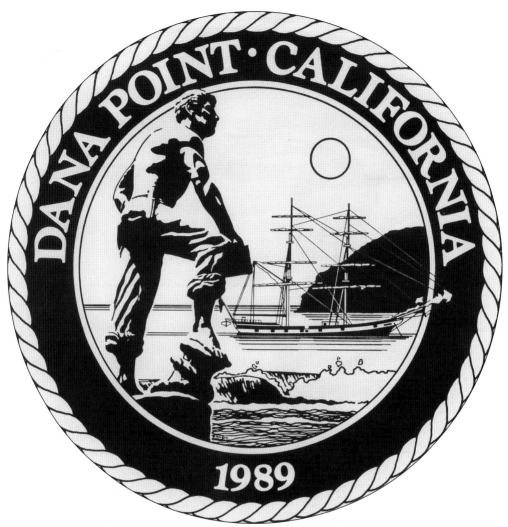

CITY SEAL. Three distinct communities that had lived side by side for decades incorporated together in 1989. Dana Point, in the center, put its official arms around Capistrano Beach to the south and Monarch Beach to the north, paving the way to become a new Southern California resort destination. The city seal features local history: namesake Richard Henry Dana and the dramatic point with the *Pilgrim*, which brought Dana here. The charter city council chose the *Pilgrim*'s deck for its swearing-in ceremony.

ON THE COVER: "Dana Point is like the Rock of Gibraltar, created upon a solid, substantial foundation. On the Pages of Time will be written its achievements." The simile in a 1920s investment brochure about the development planned for this coastal section of Orange County is obvious in this 1957 aerial photograph focusing on the headlands. The point emphasizes its coastal location midway between Los Angeles and San Diego. (Doris Walker collection.)

IMAGES
of America

DANA POINT

Doris I. Walker

ARCADIA
PUBLISHING

Published by Arcadia Publishing
Charleston SC, Chicago IL, Portsmouth NH, San Francisco CA

Printed in the United States of America

Library of Congress Catalog Card Number: 2006938522

For all general information contact Arcadia Publishing at:
Telephone 843-853-2070
Fax 843-853-0044
E-mail sales@arcadiapublishing.com
For customer service and orders:
Toll-Free 1-888-313-2665

Visit us on the Internet at www.arcadiapublishing.com

I am delighted to dedicate this book to the Dana Point Historical Society,
which celebrates its 20th anniversary in 2007.
—D. I. W.

CONTENTS

ACKNOWLEDGMENTS

The community that this book honors was named for the author of *Two Years Before the Mast*. When I worked with Dana Point's civic leaders to found a local historical society, I hardly realized that it would come to pass "two years before the city," which would incorporate in 1989.

I saw the need to delineate the origins and development of the transitioning communities in order to instill pride in their historic roots. Most of the residents then were new to the area and unaware of the colorful heritage of this segment of Southern California coast, which was also endowed with an especially dramatic geological backdrop.

Fine individuals have stepped forward through the years since to serve as officers, directors, docents, specialists, and speakers. Through their collective efforts, the society has grown in strength, purpose, and accomplishments to become a leading voice in current, as well as historical, affairs. I'm proud of the ensemble.

When it comes to the author's task of recording the text, word for word, comma for comma, of a book—and this is my 12th—it becomes a solo adventure. All the information, the implications, the outline, and the editorial and space requirements must come together in the author's mind with the challenge of producing the best possible end product, page by page, chapter by chapter, from them all. The readers are the ultimate judges.

Along the road to that end, there are individuals and resources that are greatly appreciated and must be mentioned. In the Images of America series, the photography comes first. My own collection of images compiled during 44 years in Dana Point provided most of those in this book, including very many I captured with my own inquisitive cameras.

For further photographic resources, I recommend the collections of the Dana Point Historical Society, the Orange County Archives, and the photographic library of First American Corporation, which has also preserved negatives of the entire county's past. Film negatives are themselves becoming historic relics in this digital age. One image in this book comes from an even rarer glass negative (see page 40).

I am especially grateful for the photographers of earlier eras, many unidentifiable now. Their fine work is essential to us. They were artists of the camera, as is Cliff Wassmann of Dana Point in our own era.

To confirm various morsels of information, I turned to several individual specialists. They all have my sincere appreciation for lending their meaningful thoughts. Then there was ever faithful, long-time Dana Point Historical Society officer Judy Henderson. She pondered and proofed my text as I figured and "fingered" out each chapter digitally.

Special thanks go to my husband, Jack Pierson Smith, who sidetracked me sometimes but has always supported my editorial endeavors. I'm appreciative, too, of being able to work with a personable editor like Arcadia's Jerry Roberts, who balanced Dana Point well with the many other books he juggled simultaneously. The proof is in the publishing!

INTRODUCTION

Bold and beautiful as a navigational landmark for sailing ships through centuries, the Dana Point promontory has also guided migrating whales through the ages. The equally dramatic marine terraces that rise more than 100 feet beside the point were once ocean bottom, uplifted in ancient times by violent geologic action. Evidence of a dense Native American population has shown that the local terrain was also attractive to the earliest human dwellers. Streams whose flow has slowed in the modern era provided fresh water then. The native landscape and the sea filled the people's nutrition needs.

Sheltered coves within a crescent bay became the natural anchorage for supply ships servicing the nearby Mission San Juan Capistrano in the late 1700s. It was the only port between San Diego and San Pedro, lying exactly between those two historic ports that have matured into major harbors.

The Capistrano mission, and later surrounding Mexican ranchos, supplied valuable cowhides to New England trading ships that anchored offshore in the early 1800s. These leather "California Bank Notes" were traded for manufactured goods unattainable in California, which yet lacked any factories.

One of those wind-dependent, cargo-laden vessels, the brig *Pilgrim*, had in its crew a young ordinary seaman who would elevate that ship and this rugged anchorage into lasting literary history. Richard Henry Dana called the place now named for him "the only romantic spot in California," describing its impressive setting in his classic account of that 1835 voyage, *Two Years Before the Mast*. He plays a significant character role in any account of the local history.

The Santa Fe Railroad connected its tracks between San Diego and Los Angeles at this halfway point in 1888, stimulating development of a beach town, San Juan-by-the-Sea. It lived a short life in its isolated location. Not until the 1920s was development begun on the bluffs on either side of the Capistrano Valley—Capistrano Beach to the south and Dana Point to the north. The dramatic stories of their foundings and their culminations fill two chapters of this book.

After the quiet decades of the 1930s and 1940s, urban life began again with the arrival of the San Diego Freeway in 1958, completing the modern transportation corridor between the same two large cities, with Dana Point and Capistrano Beach at the center. As a result of that new dream road for commuters, residential developments were successfully created in the beach communities. However, little industry developed except farming, ranching, and fishing around the two independent small towns.

Then history turned full circle: the long-held hope of a real small-craft port of refuge was fulfilled, as Dana Point Harbor was constructed in the former rocky coves. The construction, ending in 1971, enabled 2,500 yachts of all sizes to berth within the sheltering breakwaters and call it their home port.

In 1989, the two original towns of Dana Point and Capistrano Beach joined forces to incorporate. The coastal community of Monarch Beach joined them, all under the banner of the new City of

Dana Point. It has been in the newer section of Monarch Beach that major luxury hotels were lured by the romantic setting to complete the offerings of a coastal resort port city.

As namesake Richard Henry Dana wrote prophetically of this then wilderness land in his 1840 bestselling book, the first in English to describe California: "In the hands of an enterprising people, what a country this could be!"

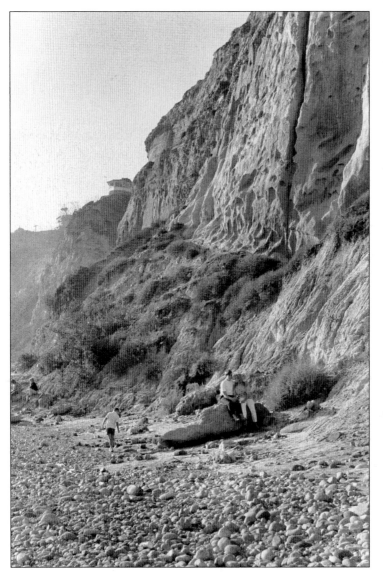

ROMANTIC SETTING. While inhabited by native people for centuries, it remained a secret to modern folk by the nature of its rugged terrain. Its definitive description as coastal California's "only romantic spot" is proven in this 1960s photograph of a couple seated on a great rock at the base of the steep cliffs that surround the natural coves. Until the construction of Dana Point Harbor in the late 1960s, this narrow rocky beach was exposed only at low tide and was reached only along steep Cove Road. The wave-rounded rocks were taken for ballast aboard 19th-century trading vessels that anchored offshore. They were carried to faraway ports, some becoming cobblestones in Boston harbor. (Photograph by the author.)

One

THE NATURAL SETTING

San Juan [now Dana Point] is the only romantic spot in California. The country here for several miles is high table-land, running boldly to the shore, and breaking off in a steep hill, at the foot of which the waters of the Pacific are constantly dashing. For several miles the water washes the very base of the hill, or breaks upon ledges and fragments of rocks which run out into the sea.

—Richard Henry Dana
Two Years Before the Mast

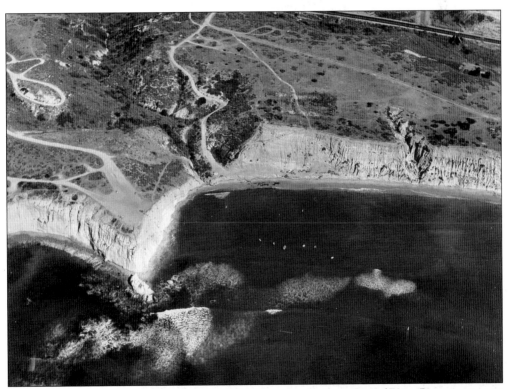

GREAT ROCK WALL. Most of the more than 7-mile coast of today's City of Dana Point is set upon high marine terraces that were once segments of the ocean floor, uplifted eons ago by cataclysmic earth eruptions. The terraces south of the headlands within Dana Point Harbor continue up to today's Doheny State Beach. The city's modern residential neighborhoods offer varying vistas of the seacoast, the Capistrano Valley, and the Santa Ana Mountains.

ROCKY REACHES. This early 20th-century visitor, while passing though, chose to be photographed within a rocky coastal setting. He holds the shell of an abalone, a species quite abundant and sought after along the south Orange County coast in those days. Because the bluffs were then uniformly planted with lima beans from Irvine to Oceanside, the only access to an ocean view would have been achieved by walking between the rigid rows of plants.

ANCIENT ROCK AND YOUNG ADMIRERS, 1920S. The rocks that circle the coves of Dana Point are a special focus for geologists. This huge boulder fell from the oldest formation of all, the Dana Point headlands. It is formed of angular rocks cemented within a hard matrix. They include rare schist rock formed about 150 million years ago. A walk along the base of the headlands reveals this blue schist embedded within a rosy-colored foundation.

SCENIC INN, 1924. Though there was no natural access to the narrow, rocky beach at the foot of the Dana Cove cliffs, and despite its isolation at high tide, the first planned development on the bluff-tops had this secluded Scenic Inn built of native beach rock. The shelter was an enticement for hardy lot shoppers, who were served promotional picnics that featured local lobster. A winding foot trail cut along the bluff-side gave access to this glorious scene.

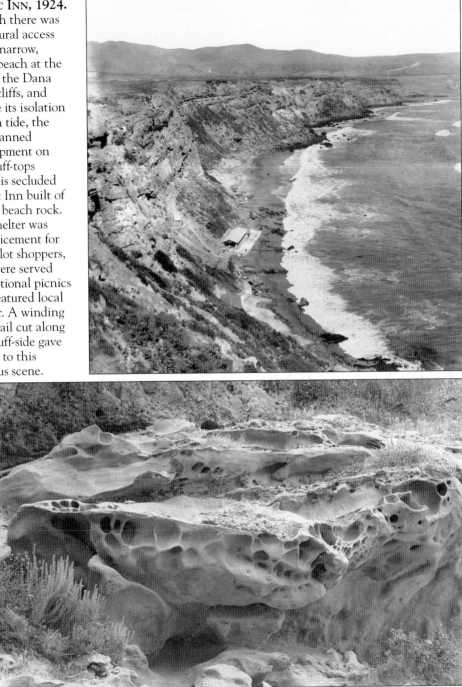

PICTURESQUE EROSION. The fine-grained beige siltstone cliffs have eroded over the ages from the forces of wind and weather, magnifying their beauty to the beholder. Pockets in their pleasingly eroded sides become natural flowerpots for rare native succulents. The swallows that brought romance to nearby Mission San Juan Capistrano once built their nests in the orifices of Dana Point's oceanfront cliffs, hence their name "cliff swallows." (Photograph by the author.)

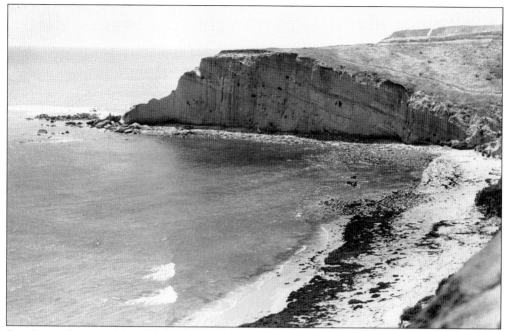

SAN JUAN POINT, 1920s. This secondary point once projected into Capistrano Bay south of the Dana Point promontory that marks the north end of Capistrano Bay. That was the natural anchorage for ships bringing supplies for Mission San Juan Capistrano, which lies three miles inland. It was the only shelter for ships between San Diego and San Pedro during 1800s hide-trading days. Capistrano Bay ends at San Mateo Point in south San Clemente.

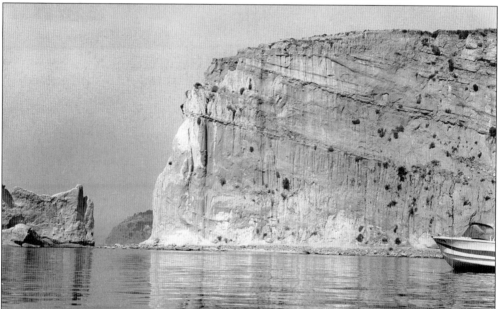

SAN JUAN POINT, 1965. Small fishing and pleasure boats enjoyed limited protection within these coves before Dana Point Harbor was begun in the 1960s. Seen here through a break in the point of Fishermen's Cove, which created an offshore stack, are the adjacent Dana Point headlands. San Juan Point was cut away during construction of the harbor. (Photograph by the author.)

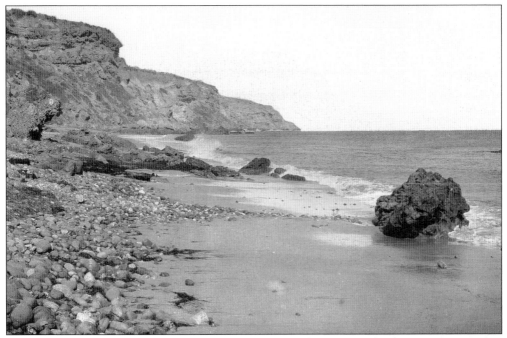

DANA COVE OUTGOING TIDE, 1880S. The north side of San Juan Point reveals the dramatic scene that would appear within Dana Cove as each ocean tide receded, revealing rocks alive with intertidal sea life from abalone and barnacles to starfish and urchins. Early wind-dependent ships had to anchor far from shore to avoid the rocky shoals.

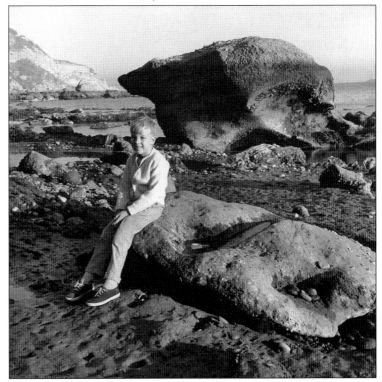

DANA COVE TIDEPOOLS, 1960S. This is the same scene within Dana Cove 80 years later at very low tide. The high-tide level can be seen near the top of the largest rock, far above the head of the author's son, Brent Walker, who grew up in Dana Point. The exposed seascape is covered with signs of life. (Photograph by the author.)

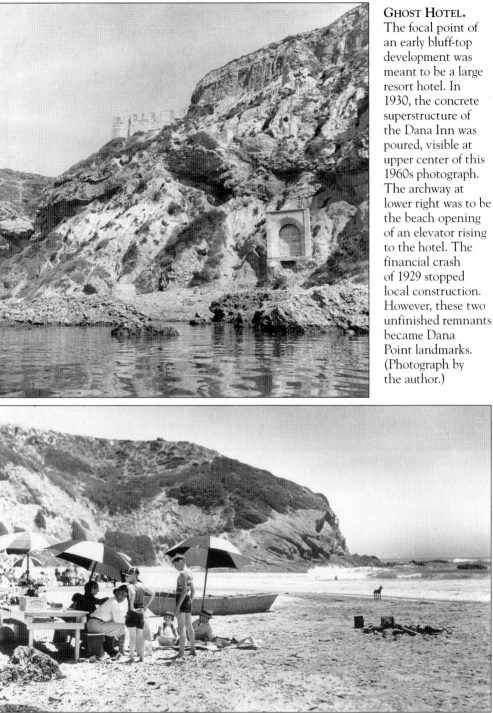

GHOST HOTEL. The focal point of an early bluff-top development was meant to be a large resort hotel. In 1930, the concrete superstructure of the Dana Inn was poured, visible at upper center of this 1960s photograph. The archway at lower right was to be the beach opening of an elevator rising to the hotel. The financial crash of 1929 stopped local construction. However, these two unfinished remnants became Dana Point landmarks. (Photograph by the author.)

DANA STRAND, 1920s. The north side of the point shelters sandy Dana Strand Beach. It was the favorite swimming stop for visitors like these 1920s picnickers, with evidence of a beach barbecue. Rowboats could be launched there and dogs were allowed to roam the beach. This one was spending a pensive moment analyzing the surf.

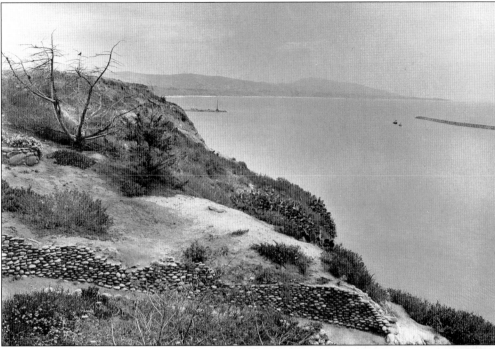

BREAKWATER BEGINS, 1966. The romantic bluffs and rocky shore would forever change with the construction of Dana Point Harbor. Here the east and west breakwaters grow toward each other. The curve of Capistrano Bay beyond leads to the Capistrano Beach portion of Dana Point and then to San Clemente. Remnants of a rock-lined stairway down the bluffs were still in place. (Photograph by the author.)

HEADLANDS TRAIL. At low tide, adventurous hikers can make their way around the face of the headlands from the marine preserve at its base. Their reward is the discovery of sea caves carved by waves into the bedrock said to contain unidentified bones. The caves were once thought to hold hidden pirate treasure, perhaps from the shipwrecked Spanish galleon known to lie offshore. (Photograph by the author.)

NATIVE AMERICAN PROFILE ROCK, 1960s. The Dana Point promontory has several sides (as seen in the book cover's aerial photograph). One that slips into view from certain spots within the modern harbor is the dramatic profile of a Native American, chiseled by nature on the face of the rock. It watches for new arrivals by sea, guarding the ageless treasures of this natural setting. Local Native Americans no doubt used the promontory as a lookout point. (Photograph by the author.)

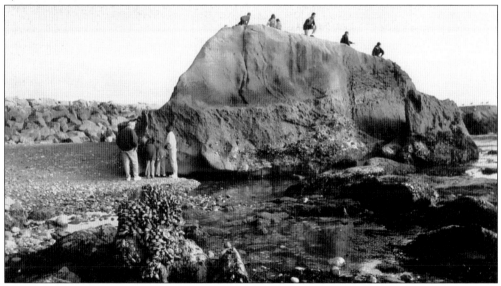

MONUMENTAL ROCK. Lying 300 yards offshore of Dana Cove, San Juan Rock attains monumental proportions at a very low or minus tide. Then it becomes a towering climbing wall for those who dare to reach the top, where there is an unbroken ocean view. Others, standing at its base, appreciate the sea-level mark that reaches above their heads. The harbor's west jetty lies beyond in this 1980s view. (Photograph by the author.)

Two

EARLY VISITORS BY LAND AND SEA

Just where we landed was a small cove, or "bight," which gave us, at high tide, a few square feet of sand-beach between the sea and the bottom of the hill. This was the only landing place. Directly before us, rose the perpendicular height.

—Richard Henry Dana
Two Years Before the Mast

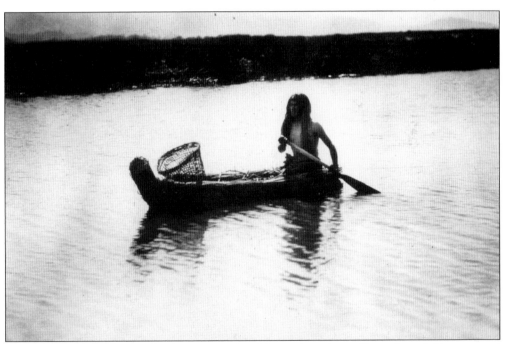

NATIVE SAIL-INS. Thousands of years ago, when Native American villages dotted this coast and its creeks, a trade developed between the residents and the natives who inhabited the Channel Islands. The island people built bundled reed boats to reach the coast. They brought their specialties—such as Catalina soapstone fashioned into bowls and effigies—to trade for local products: woven baskets and items made from abalone shells.

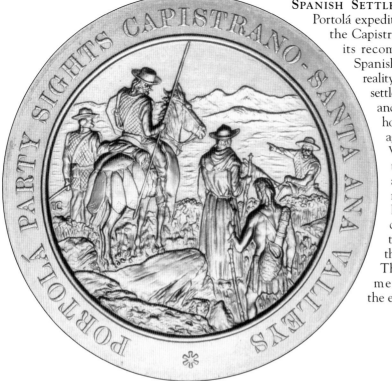

SPANISH SETTLEMENT. After the Portolá expedition passed through the Capistrano Valley in 1769, its recommended site for a Spanish mission became a reality in 1776. The mission settlement brought padres and soldiers, cattle and horses, and religion and agriculture to the area. Visitors from Europe took up residence, and then converted natives to a new lifestyle. Sailing ships delivering supplies to the mission unloaded them in the local coves. This commemorative medallion depicts the expedition.

DANA POINT'S OWN PIRATE. In 1818, Hipolito Bouchard led a mercenary fleet to plunder Spanish settlements and turn their residents against that European power. His two ships landed in Capistrano Bay. Crews rowed longboats carrying ships' cannons up San Juan Creek to plunder the mission town. However, everything of value had been wisely evacuated. What Bouchard did gain was his name on the state historical marker overlooking the bay—the only documented pirate attack in Southern California.

VISIT OF NAMESAKE DANA. He was only 20, an urban Boston citizen, a Harvard student, and a future lawyer who specialized in maritime cases. But life changed for Richard Henry Dana when he touched shore here in 1835. The modern city and harbor have followed in his foot and sea steps to commemorate those days of sail with an annual Tall Ship Festival, with a re-creation of his ship docked within Dana Point Harbor.

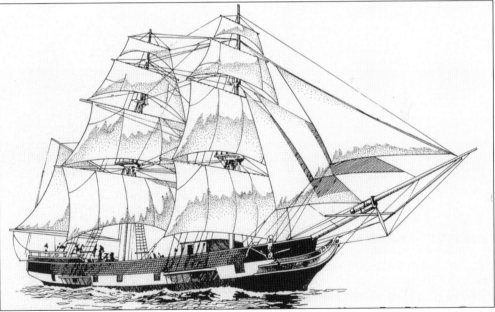

FAMOUS BRIG PILGRIM. Today more than 2,500 yachts call Dana Point their home port, but this small two-masted sailing ship is the most famous vessel ever to anchor in Capistrano Bay while on its trading route from Boston in 1835. Ordinary seaman R. H. Dana had poetic praise for the local coves, though he spent only parts of two days here. His account appears in his classic book of the voyage, *Two Years Before the Mast.* (Drawing by Warren Schepp.)

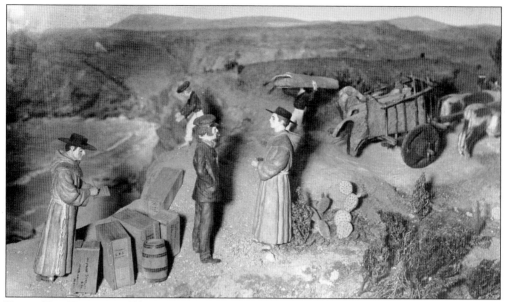

BLUFF-TOP TRADING. This museum panorama simulates the arrival of cowhides via Mexican oxcart (*carreta*) to be bartered by mission padres with visiting trading ships bringing finished goods in barrels, boxes, and baskets, all from faraway ports. The barren bluffs show sparse scrub and native prickly pear cactus. The Capistrano mission's grazing grounds extended to the coast along what is now Dana Point.

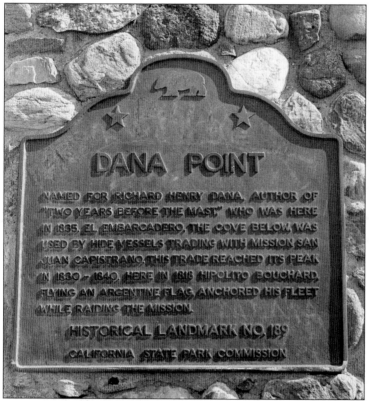

STATE HISTORICAL LANDMARK 189. This state historical marker commemorates Richard Henry Dana's 1835 visit at the Blue Lantern lookout above Dana Point Harbor. It also notes the landing of mercenary pirate Hipolito Bouchard in 1818. Another state marker two miles south on Pacific Coast Highway honors Dana's visit "in the glamorous days of the ranchos, 1830–1840. Yankee vessels traded supplies for hides here." (Photograph by the author.)

CALIFORNIA BANK NOTES. Cowhides were thrown over the bluff-tops to waiting ships' crews. They were called California bank notes because they were the only medium of exchange here. Hides that caught in the cliffsides were retrieved by the sailors, including Dana, in this re-creation. The hides sailed back to Boston leather factories and made into shoes, boots, and saddles to trade again. (Photograph by the author.)

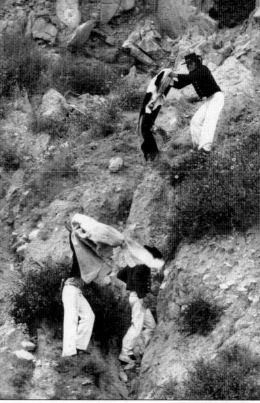

SILVER SPURS AND SADDLES. A commemorative California bank note is shown, together with silver spurs. These are a reminder that early sailors rented rancho horses for land transportation. After slaughter, cattle carcasses were tossed over the Dana Point cliffs. There, on the local "dump," they provided banquets for native scavengers: condors, coyotes, and grizzly bears. (Photograph by the author.)

California Bank Note

Let us turn back the clock to 1826 and for the next twenty years thereafter, when there were no banks or letters of credit and there was very little currency, if any, in California.

Almost all business transactions were carried on by barter. Cattle hides, "California bank notes", as they were called from Alaska to South America, had a fluctuating value of from one to three dollars.

The hides were exchanged for all types of manufactured articles. These were carried by ships sailing chiefly from New England. The hides, in turn, were manufactured into shoes and other leather goods which gave a hefty profit of at least 300 per cent. Not bad — especially when the dollar had a greater purchasing power than it has today.

WORKING
CATTLE BRAND
RANCHO
MISSION VIEJO

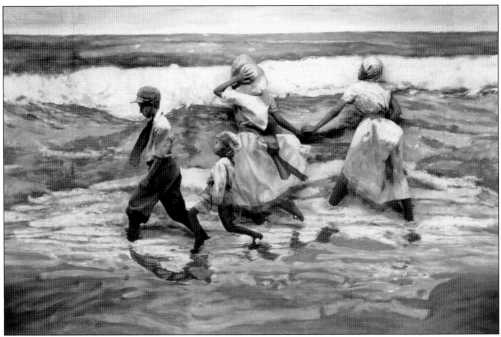

EARLY OCEAN BATHERS. There was no road along the coast yet, but when the railroad came through the area in the late 1880s, it brought inlanders down to the sea at south Orange County. Ocean bathing became a new pastime. The scene was captured in this painting, *Children by the Sea*, by Edward Henry Potthast. Here the artist's work was re-created by the Pageant of the Masters in Laguna Beach, Dana Point's next-door neighbor. (Courtesy Festival of Arts.)

PATHWAY TO LAGUNA. At the beginning of the 20th century, fields of dry-irrigation crops dotted the bluffs through what is now the Monarch Beach section of Dana Point. There was only a dirt road, as the coast highway would not arrive until 1929. Niguel Hill, rising above the scene at right, blocked television reception into Dana Point until cable service was introduced in the 1980s.

BRAVE BOATERS. Occasional yachts of all sizes ventured along this coast in the 1920s. No harbor of refuge existed between San Diego and Newport Beach, which itself was still an underdeveloped bay. Here one crew stops for a photograph by another passerby beside the rugged cliffs of Dana Point four decades before they would enclose a modern harbor of refuge, berthing, and recreation.

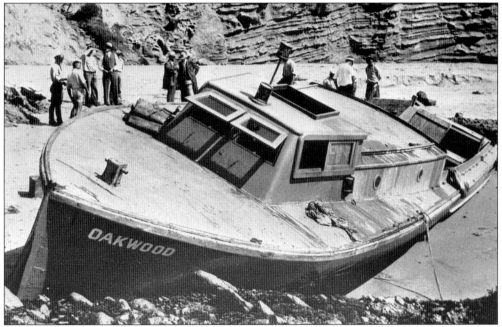

RUMRUNNER RUNS AGROUND. Salt Creek Beach gained notoriety during Prohibition in the 1920s when the rumrunner yacht *Oakwood* went aground there. This "fast boat" was carrying a cargo of illegal whiskey acquired from a Canadian "cruise ship" anchored offshore in international waters but came too close to shore at low tide. The Canadian ship was really a floating liquor warehouse. Revenuers and enforcement officers confiscated the goods, the boat, and the rumrunner.

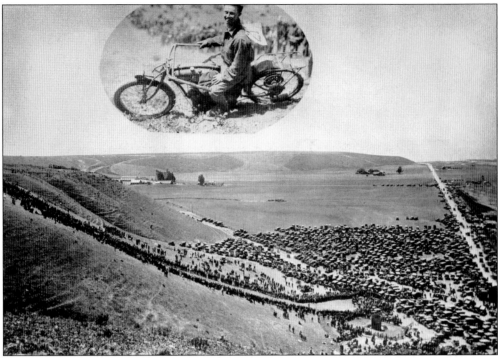

THE HILL OF THRILL. Dana Point's first crowd event occurred annually *c.* 1917–1927: the Capistrano Hillclimb. The valley came alive with motorcycles, motorcars, and as many as 50,000 spectators. In this 1921 photograph, they lined Doheny Park Road and the uphill track to what is now the San Diego Freeway. For years the hilltop wasn't reached thanks to the near-perpendicular incline. Dudley Perkins and his Harley made it, and went on to national fame.

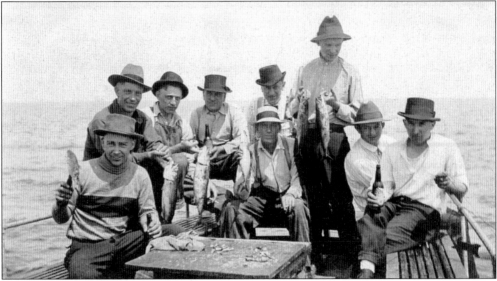

SPORTFISHING, 1920s. Felt fishing hats were the mode of the day for sportsmen who gathered at Dana Cove and ventured out to sea. Fishing boats left from both the Dana Cove and Capistrano Beach piers. The anglers shared fish stories before and after the catch, as well as bottled beer—only beyond the three-mile limit, of course, Prohibition then being the law of the land.

Three

EARLY RESIDENTS ON SHORE AND ON HILLS

There was a grandeur in everything around, which gave almost a solemnity to the scene . . . the great steep hill rising like a wall, and cutting us off from all the world but the world of waters!

—Richard Henry Dana
Two Years Before the Mast

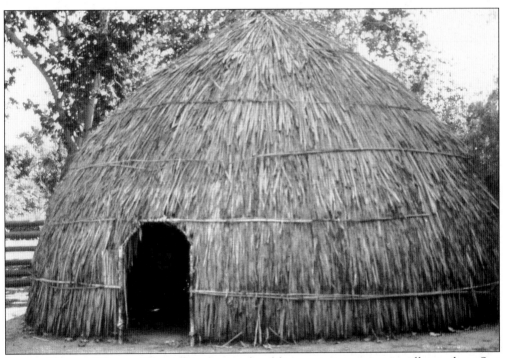

LOCAL NATIVE HOMES. The earliest known local living quarters were in villages along San Juan Creek and other fresh water sources. Each family gathered reeds from the shores and wove a thatched hut (*kiitcha*) that was wind- and water-resistant. An opening in the roof served as a vent when indoor fire was needed for cooking and heating. Replicas like this one can be seen at various locations. (Photograph by the author.)

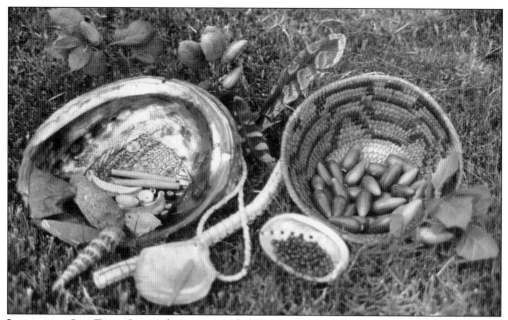

LAND AND SEA FARE. Live oak trees provided Native Americans with their staple food, meal made from the long tapered acorns. They also gathered seeds and berries. Life on the coast offered plentiful fish and seafood: mussels, clams, lobster, and abalone. Shells of the latter were useful for dishes, jewelry, and fishhooks. The local Ahachemem (Juaneno) people were excellent basket weavers. Tight-woven baskets were even used as cooking utensils. (Photograph by the author.)

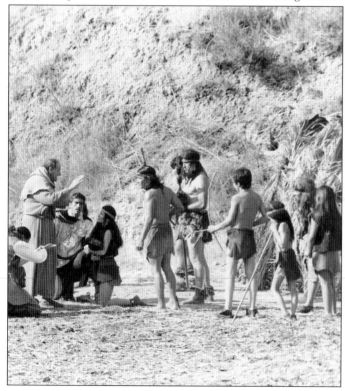

CHANGE OF LIFE. After the site for a mission settlement was selected in San Juan Capistrano, its padres lured the local natives into a dramatically different lifestyle. They planted food instead of gathering what nature provided. They built houses of adobe bricks, incorporating the local soil. Spanish religion and education were added to the daily agenda. The pictured re-enactment was part of a local historical pageant. (Courtesy Dorothy Fuller.)

SPANISH FLAVORS. The Capistrano Mission added new cultural ideas, such as colorful clothing—seen in this photograph—instead of animal skins. Cloth was woven by the natives, as were blankets. Other industries added to the workday included raising domestic animals and production of wine, candles, and soap. The people moved into closer quarters within the mission complex.

CULTURAL MIX. Life at the Capistrano mission during the 1800s saw a mix of people interacting. Natives, cowboys, ranchers, and bandits all played their parts. While vast acreage beyond the immediate area was granted as private ranchos, the mission land that would become Dana Point was sold later in smaller lots. Part of what became Capistrano Beach was a section of Rancho Boca de la Playa.

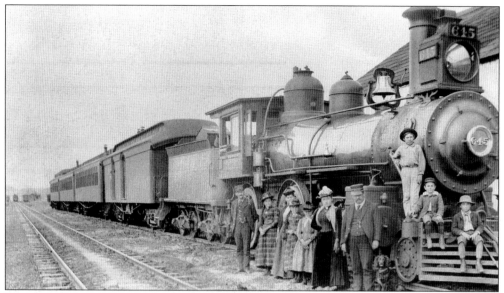

RAILROAD REVOLUTION. Another new dimension to rural life came with the railroad. The California Central, affiliated with the Santa Fe, laid tracks between Los Angeles and San Diego. They reached the midway Capistrano Valley by 1888. Steam engines became a magnet of attention for local residents. They gathered to watch the powerful trains pull into view. Then they surveyed the passengers getting off, wondering if these were new neighbors.

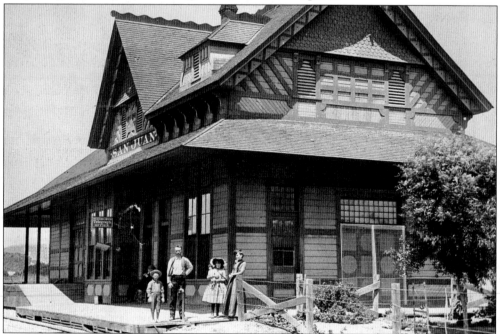

SAN JUAN STATION. Dana Point got its only railroad station at today's Capistrano Beach, then called San Juan-by-the-Sea. The fancy frame structure at Victoria Boulevard was completed in 1887, when the tracks from Los Angeles ended there. Santa Fe's subsidary, Pacific Land Improvement Company, added a spur track to the beach, then laid out the town. Lot buyers stood in line all night before the tract opened that year.

SAN JUAN-BY-THE-SEA. A bathhouse, dance pavilion, hotel, and shops were built in the new town, and residences dotted some lots. Excursion trains brought prospective buyers to view the "city," where free fiestas featured bullfights. Internationally famous Shakespearean actress Helena Modjeska, at right, and her husband built their home in an Orange County canyon now named for her, but the grand Polish lady also fell in love with life in San Juan-by-the-Sea. She rented the small Pioneer Hotel, then entertained her entourage of European friends at her "summer camp." The town charmed a select clientele but not enough visitors to support business. John and Mary Sharps saw the handwriting on the walls of their Pioneer Hotel, so they had it cut into three pieces and hauled to Newport Beach, where it became Sharps' Hotel. It served as a boarding house for workers building the docks there.

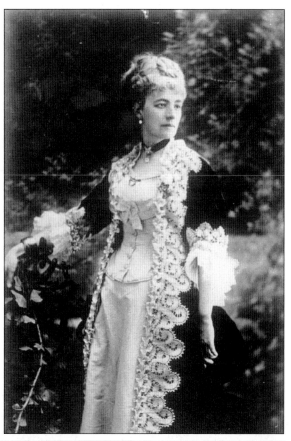

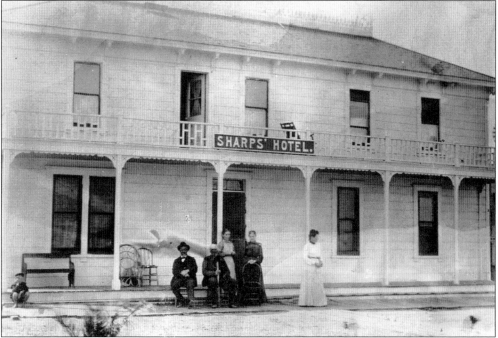

29

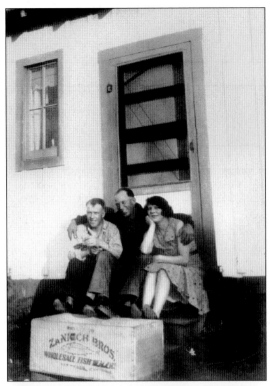

HOME IN THE COVE. If home is where the heart is, home for Dana Point's early-1900s residents was where the sea met the shore in Dana and Fishermen's Coves. These were fisher people dependent on the sea for their food and their livelihood. They built simple shacks and seemed oblivious to the steep cliffs "cutting us off from the rest of the world but the world of waters," as Dana wrote. The cliffs were scaled with gusto, remindful of the earlier hide traders' cliff-scaling feats.

TARPAPER SHACKS. In the early 1900s, simple homes in Dana Cove held happy residents. Fishermen launched their boats (see one at right) along the sand or on rollers. The thick kelp beds along the shore held ample small baitfish. Those who didn't put to sea worked the tidepools, which were filled wall-to-wall with mussels. A group of Russian fishing families arrived suddenly, built their own shacks, then left when their country was invaded in World War I.

LOBSTER KING, 1911. The first to really settle into Dana Cove was Art Pobar. He would make it his lifelong home. Native spiny lobster that had lived in those waters for decades now met their match. Pobar and his buddies trapped lobsters that were 3 to 4 feet long and weighed an average 12 pounds. They were kept alive in gunnysacks tied to the rocks, then driven to restaurants around the growing art colony of Laguna Beach.

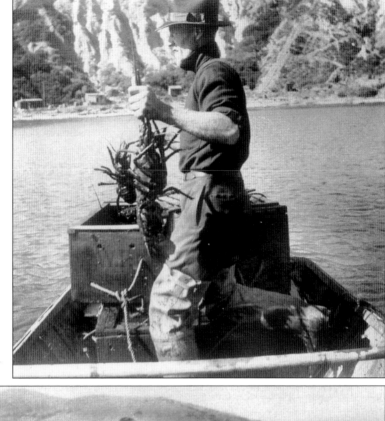

MARKETING FRESH FISH. Early fishermen hand-dug the first cove road. They kept a horse-and-buggy at the top. Maude the horse was driven to the railroad's water towers in Serra, which had been San Juan-by-the-Sea. The catch—bass, barracuda, mackerel, and bonita—was loaded aboard the train when it stopped to fill its boiler tanks. Maude also hauled fresh water from San Juan Creek back to the cove, where it was lowered by hand pulley down the bluff for the cove dwellers' use.

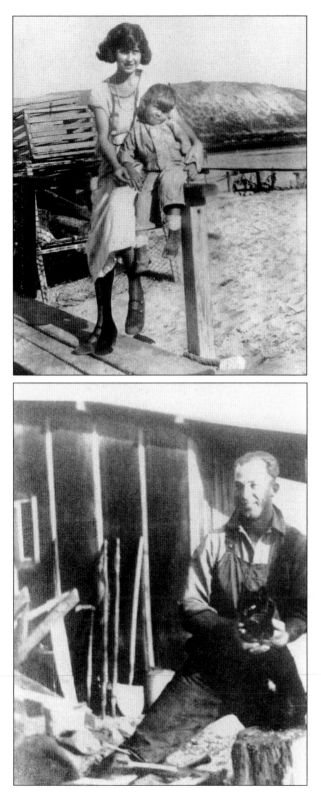

COVE KIDS AND PETS. Shirley Pobar Schlosser, seen here with her mother, grew up in Dana Cove. After her parents separated, she still spent summers with her father there (below). Even though the grand bluff-top plans for Dana Point ended in the 1930s, she felt she was in a wonderland. The bean fields that spread across the upper reaches had been magically subdivided into a new playground. She and her cove friends roller-skated on the empty concrete streets and sidewalks lined with lovely lantern lampposts. Hardly anyone lived there. The cove kids also had much of the beach to themselves and a few sea-seasoned pets (find the black cat). When the fishermen came home at day's end, the kids played "going to sea" in the beached dories.

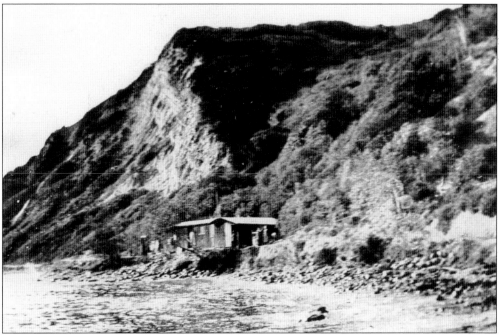

ROCKY FRONT YARD. One of the Dana Cove residents, who raised his family in this simple shack, went on to give the rocks a more royal treatment. When the first Dana Point tract came into being in 1924, the Seeman family thought they lived in paradise. When Ed Seeman was commissioned supervisor of roadway improvements for the San Juan Point development, Ed and his brother George went to work creating decorative features from the native beach rocks. They hand-set the stones that formed the Scenic Inn on the beach and created an intricate rock-lined path from the gazebo above down to the picnic pavilion. It included six "lovers' landings" along the way for hikers to rest and luxuriate in the ocean view.

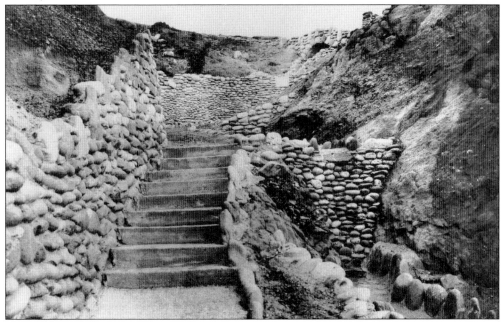

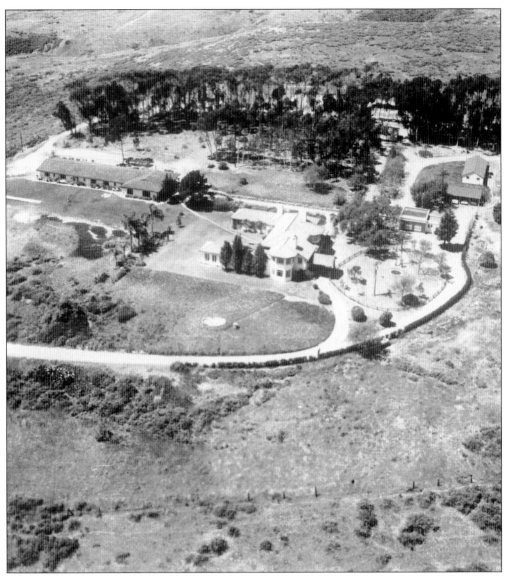

DOLPH SISTERS' OASIS, 1914. They left Scranton, Pennsylvania, to live way out west. They chose this undeveloped yet acclaimed "only romantic spot in California." With income inherited from the family coal mining business, Blanche Dolph, with her sister Florence, commissioned the first permanent residence in Dana Point. The magnificent two-story mansion and outbuildings stood on 25 acres of land high above McKinley Avenue (now Del Obispo Street). It is still there.

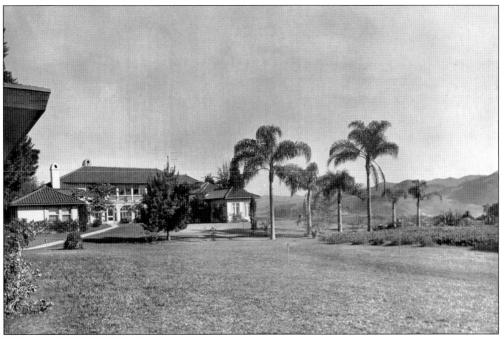

PANORAMIC VIEW. The 360-degree Dolph property's view was of the ocean, the valley, and the mountains. The palm trees they planted stood tall along the skyline. A neatly trimmed lawn replaced the rough native scrub. The house came to be called the Dolphin. Those frisky marine mammals were near neighbors, providing live entertainment to those who focused on the sea view.

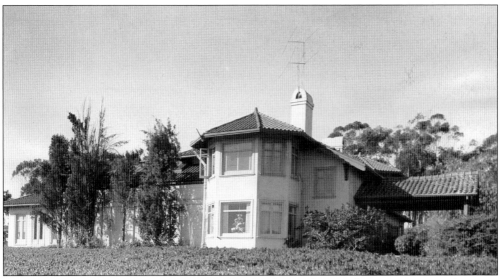

THE DOLPH HOUSE WAS A MASTERPIECE. Besides the usual array of necessary rooms, there was a music salon, a skylighted conservatory, a servants' wing, an attic, and a basement. The porte cochere, at right, framed the front entrance. Part of the Dolph property was combined with other families' holdings in 1912 to create Dana's Point Company, the first use of that name to identify a section of land. The Dolph land included knolls along present Del Obispo Street, ocean-view property east of Street of the Golden Lantern, and part of Rancho Boca de la Playa.

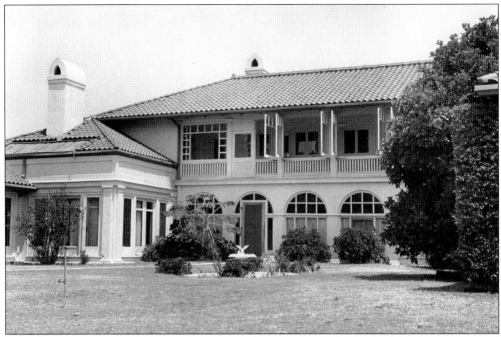

UPTOWN, DOWNTOWN. Fisher families were content with simple shacks, like the one pictured below with a rocky front yard and a steep hill for a backyard. At the same time, in the early 1900s, their uphill Dolph neighbors enjoyed the luxury of interior paneling and staircase banisters of fine Honduras mahogany, which had been shipped from Central America to San Diego and then carried by train to San Juan Capistrano. The steep roofs were fashioned of imported red tiles in contrast to the flat frame roofs below. In the cove and on the hill, these were probably the only homes in town.

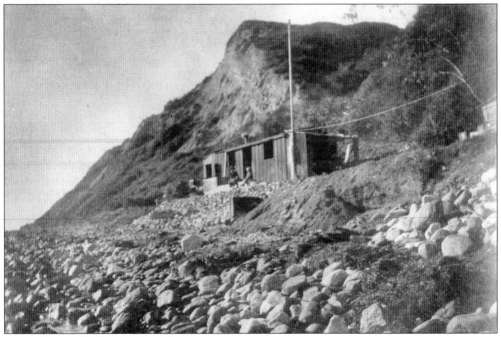

Four

SERRA–
CAPISTRANO BEACH

A town is like a man—or a woman: you must know something of its early life, its struggles, its triumphs, of what it has stood for in the past, as well as what it stands for now.

—Hildegarde Hawthorne
Poet and granddaughter of novelist Nathaniel Hawthorne

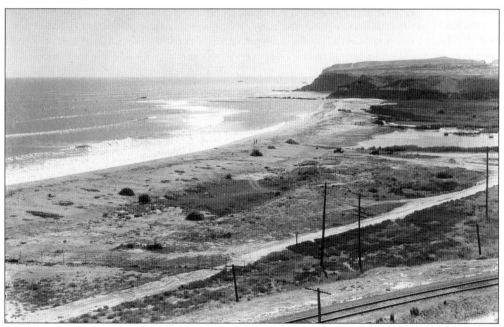

TRAIN TRACKS OPENED AREA. When the railroad came through in the 1880s, it had to turn its tracks toward the coast to avoid the foothills. San Juan Creek flowed into the ocean at this point. The beach, shown in the early 1900s, was waterlogged and swampy. The terraces of Dana Point provide the backdrop. This lowland valley was a gentle break in the high cliffs that surround most of Capistrano Bay. The beachfront remained undeveloped long after the demise of San Juan-by-the-Sea in the 1890s. Renamed Serra for the founder of the mission, its small-town atmosphere would linger even as grandiose 1920s developments were to begin on both sides of the valley.

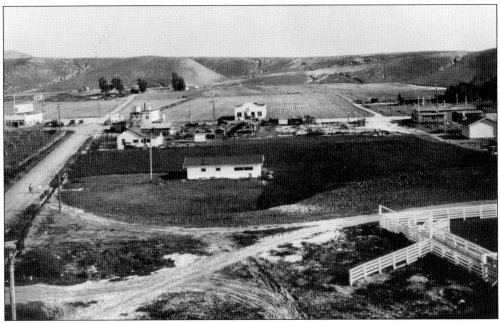

SERRA NECESSITIES, C. 1920. The San Juan-by-the-Sea train depot still stood at the end of Victoria Boulevard (off photograph at left). The all-important water company occupied the center field, while along the main street were clustered the other necessary structures, from left to right: the pool hall, the Serra Hotel, the automotive garage, a restaurant, and one of the town's three one-room schools. Both Capistrano Beach and Dana Point developments would depend on local water wells.

SWEEPING VIEW OF SERRA VILLAGE, 1920S. This scene from the ice plant–covered bluffs of Dana Point overlooks the Capistrano Valley and the town of Serra. To the right of a large citrus orchard can be seen the two tall towers that held water for the boilers of Santa Fe steam trains that stopped there of necessity when passing through between Los Angeles and San Diego. By then, Serra had become just a flag stop for passengers.

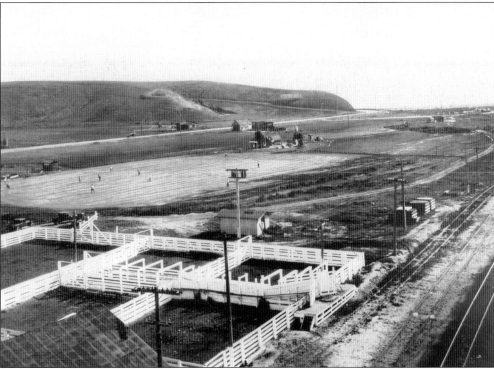

BASEBALL AND CATTLE. Beyond the dirt baseball field at center, where teams from San Diego and Orange Counties met, was a small building housing the water well. From the train tracks off to the right, cattle were unloaded into the waiting holding pens. From there they were driven into the hills to feed lots, where they echoed the stance of the baseball game's waiting outfielders. When fattened, the cattle could expect their last roundup back to the corrals and their last train ride.

RURAL ROAD, LATE 1920S. The outskirts of the Capistrano Bay towns were rustic and unassuming. Homes were basic and amenities were outside, including laundry tubs and wells. There were signs advertising the ample real estate. One sign shaped like a coffeepot, across the road from this house, promoted MJB coffee. Traffic jams were not yet a problem. (Courtesy Orange County Archives.)

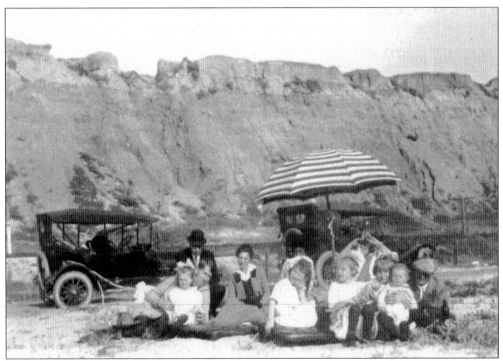

COASTAL SUNDAY DRIVE, 1920S. Families in their Sunday best dress began to make the local coast their destination, where they chose a spot between the rugged bluffs and the sea for a picnic stop. Here two families rendezvous and share one umbrella at the foot of the Capistrano Beach bluffs while all the children sit politely for the camera. This is a print from a rare glass negative.

HALFWAY CAFÉ. The fact that this area was exactly the halfway point between Los Angeles and San Diego was well advertised, here on the sign at far right for the "Palm Café, Halfway House." It was a leading restaurant in downtown San Juan Capistrano. Farm wagons and animal pens indicate that there was more than one way to earn a living in those good old days. (Courtesy Orange County Archives.)

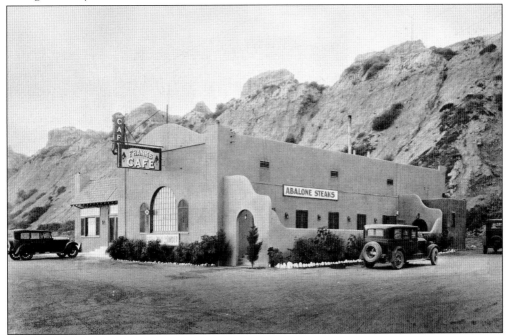

FRESH SEAFOOD SERVED HERE. Motorists who preferred to satisfy their salt-air appetites out of nature's elements had this early restaurant, Frank's Café, to enjoy. Set at the base of the coastal bluffs of Capistrano Beach, it offered as specialties fresh clam chowder and abalone steaks thanks to the local fishermen who welcomed this handy outlet for their daily catches.

DOHENY MANSION. When oil heir Edward (Ned) Doheny Jr. acquired nearly 1,000 acres along three miles of beachfront and on the palisades above, he planned a Spanish residential development: Capistrano Beach. This cliff-top, ocean-view home, which came to be known as the Doheny Mansion, was then named Palisades House No. 1. It was the private guesthouse for the Doheny family of Beverly Hills. Thirteen miles of winding streets and residential lots, ranging from beach cottage pads to three-acre villa lots, surrounded it. So far, this very historic home remains in place, though it is threatened (Photograph by the author.)

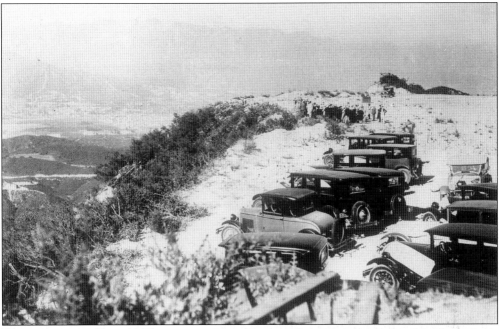

VIEW FROM THE TOP, 1927.
Would-be lot purchasers were
driven to the top of the palisades
to view the Capistrano Valley
looking northwest. Beyond the
cluster of parked motorcars, a
group of visitors who ventured
over the uneven terrain can be
seen listening to a stirring real
estate talk about the wondrous
development that was promised
there at "the top of the world."

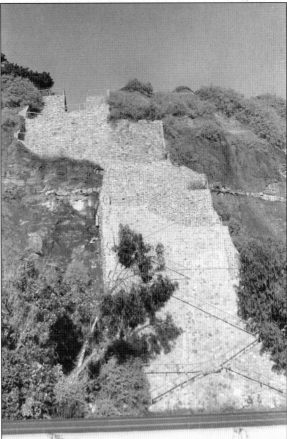

PEDESTRIAN STEPS. An elaborate
stone stairway began at the
extensively landscaped gardens
of the bluff-top Doheny Mansion,
pictured on the opposite page. The
steep steps crisscrossed down to
the coast highway and the private
white-sand beach below. They slowly
began to disintegrate about 1970.
(Photograph by the author.)

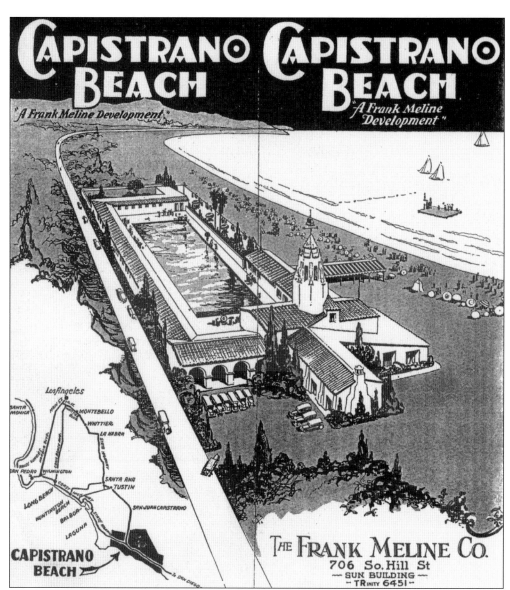

CAPISTRANO BEACH CLUB FOCUS. This 1927 sales brochure for Ned Doheny's Capistrano Beach announces it as "A Frank Meline Development." Meline was a noted Los Angeles architect and developer who designed many celebrity homes and quality Southern California tracts during the early 1900s. Meline's company was given exclusive sales management of the new Doheny property, which was owned by Petroleum Securities Corporation as a "civic enterprise." That Los Angeles firm was owned in turn by the developer's father, Edward L. Doheny, who made the family fortune in the Southern California oil industry. Architect Meline designed such classic buildings as Hollywood's Garden Court Apartments. That early example of multiple dwelling units is now on the National Register of Historic Places.

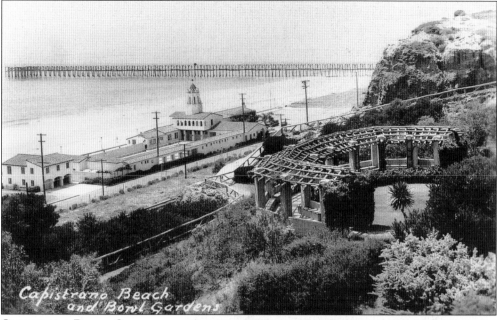

Capistrano Beach
and Bowl Gardens

CAPISTRANO BEACH CLUB.
While residences were built in the palisades, this towered beach club was the focal point below the coastal cliffs. It was meant to be the private "sand castle" for families who would inhabit the Spanish residences above. It was topped with 50,000 hand-made red roof tiles, even on the 55-foot-high tower that, floodlit at night, became a literal lighthouse. Several wings held various services in a European castle–like layout. Guesthouses were built along the beach beside it. Doheny's 1,200-foot wooden fishing pier can be seen beyond the club. Above the site were landscaped gardens with a gazebo from which to enjoy the ocean panorama. Spanish wrought-iron accents to the beach club included this artistic entrance gate with a swallows theme and initial C for Capistrano. (Photograph at right by the author.)

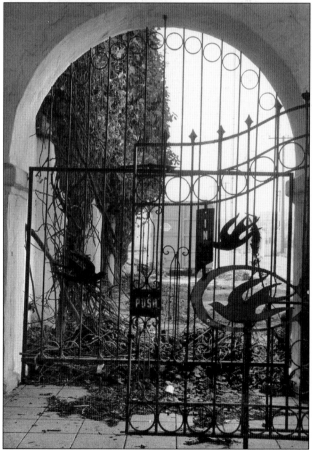

45

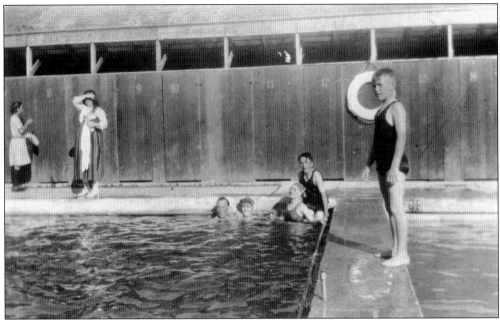

BEACH CLUB OPENING DAY. A 100-foot pool was enclosed within an outdoor patio. Dressing rooms lined its side, as these charter guests tested the pool. The club also had a large ballroom, a marine dining room, and the Swallows' Nest bar and grill. After Capistrano Beach development construction ceased in the 1940s, the club became a gambling casino and then a private recreation club. It remained a community asset for decades, hosting public swimming classes.

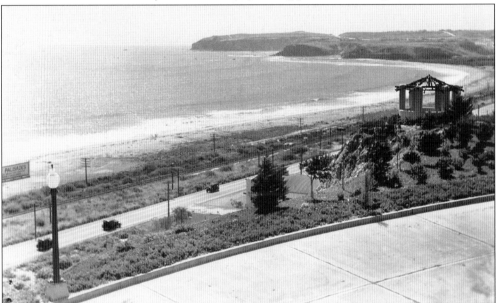

VIEW FROM THE PALISADES, 1929. From atop the cliffs at newly paved Palisades Drive, a growing flow of motor traffic could be viewed traveling the new highway. The lookout gazebo, seen at right, was set in a landscaped garden alongside the Doheny Palisades development. The distinctive streetlamp at left was repeated throughout the community's main streets, including Estrella Mall.

Los Angeles Examiner

Telephone Classified Ads to
MEtpoltn. 4000
or bring them to any
EXAMINER OFFICE
1111 S. Broadway, 508 S. Broadway
105 S. Broadway

VOL. XXVI—NO. 69 LOS ANGELES, MONDAY, FEBRUARY 18, 1929 PRICE FIVE CENTS

DOHENY JR. SLAIN BY HIS SECRETARY

NEW DOPE BILL UP TODAY IN LEGISLATURE

Would Make Cash Compromise on Narcotic Charge Basis for Revoking Physician's License

By A. M. Rochlen

California wants no compromise with "technical" murderers who crush bodies and souls with "minor violations" of dope addiction laws.

While Washington officials are busy explaining how and why more than 1200 cases of Harrison Narcotic Act violations were settled with the Federal Government in 1928 for cash and without court trial, this state is preparing to enact a law making such compromises by physicians sufficient cause to revoke medical licenses.

Senate Bill No. 217, intrintroduced by Senator John J. Crowley of Los Angeles and Senator Sanborn Young of Los Gatos, chairman of the state narcotic committee, proposes changes of the present medical act, and will come up for action when the Legislature reconvenes today.

"Conviction of or cash
(Continued on Page 2, Columns 1-2)

Unfair Taxing Charged on Film Salaries

Levies Based Upon Temporary High Pay; 'Lean' Years Unnoticed, Players Complain

BY LOUELLA O. PARSONS
Motion Picture Editor of Universal Service

"Taxation without representation is tyranny!" These words have rung down the years since the historical Boston tea party was the first stepping stone to America's glorious independence. Today these words have come to have an ironic meaning to some of our motion picture people in Hollywood, who have been so flagrantly and unfairly treated by the income tax collectors.

The situation is almost as outrageous as it was in France when taxes were farmed out to collectors who took dastardly and unfair means to plunder the public.

Use Reputed Salary

(Continued on Page 3, Col. 1.)

Victim of 'Madman'

EDWARD LAURENCE DOHENY JR., millionaire oil man, who was slain Saturday night by his confidential secretary, Theodore Hugh Plunkett. —Examiner photo.

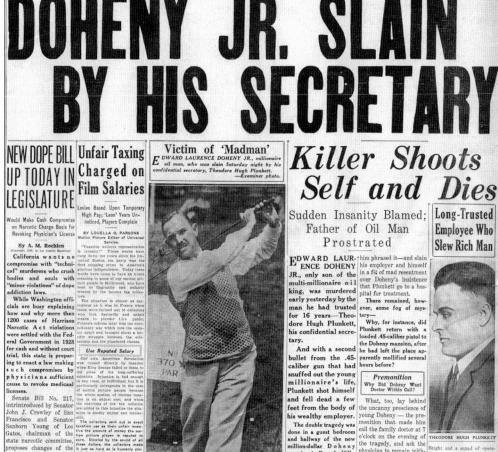

Killer Shoots Self and Dies

Sudden Insanity Blamed; Father of Oil Man Prostrated

EDWARD LAURENCE DOHENY JR., only son of the multi-millionaire oil king, was murdered early yesterday by the man he had trusted for 16 years—Theodore Hugh Plunkett, his confidential secretary.

And with a second bullet from the .45-caliber gun that had snuffed out the young millionaire's life, Plunkett shot himself and fell dead a few feet from the body of his wealthy employer.

The double tragedy was done in a guest bedroom and hallway of the new million-dollar Doheny mansion in Beverly Hills, at the very moment that Doheny's terrified wife was admitting the family physician, who had been hastily called to quell Plunkett's murderous frenzy.

Resentment
Doheny Insisted Plunkett Go to Hospital

And for that murderous frenzy, the family and the doctor and officials yesterday had but one explanation—that Plunkett, harassed by illness and the weight of his work, had culminated six weeks of nervous breakdown by going suddenly insane—"completely off," the family doctor who had treated

—him phrased it—and slain his employer and himself in a fit of mad resentment over Doheny's insistence that Plunkett go to a hospital for treatment.

There remained, however, some fog of mystery—

Why, for instance, did Plunkett return with a loaded .45-caliber pistol to the Doheny mansion, after he had left the place apparently mollified several hours before?

Premonition
Why Did Doheny Want Doctor Within Call?

What, too, lay behind the uncanny prescience of young Doheny — the premonition that made him call the family doctor at 7 o'clock on the evening of the tragedy, and ask the physician to remain within call in case Plunkett came back?

And what was the colloquy that took place between Doheny and Plunkett in the moments that just preceded the double shooting?

These are questions that may never be answered—although yesterday, the full forces of the district attorney's office, under the personal direction of District Attorney Buron Fitts; of the sheriff's office, under Capt. William Bright of the homicide detail, and of the Beverly Hills police department, were concentrated on an investigation that was to take in every phase of the secretary's life and his relations with his employer.

All day yesterday Fitts' forces investigated and questioned witnesses. With Fitts in his office were Chief Investigator Lucien Wheeler, Captain

Long-Trusted Employee Who Slew Rich Man

THEODORE HUGH PLUNKETT

Bright and a squad of operatives.

They interviewed all persons connected with the case, including Doctor Fishbaugh and servants at the Doheny home. The Doheny family was represented by Judge Charles Well-

Tia Juana Results

Cameraman Just Won't Let Tunney Stop Fighting

CANNES, France, Feb. 17.— (Universal Service Special Cable.)—Gene Tunney, out walking on the promenade here this afternoon with Mrs. Tunney, had occasion to encounter with a French photographer which ended disastrously for the cameraman. Gene was highly indignant when the photographer kept insisting on taking pictures of them.

When he refused to heed Tunney's warning and was getting his camera in position for action, the heavyweight champion gave him a wallop which knocked him down. The champion then calmly resumed his walk.

if it's a HOME for RENT

... take this easy and quick means of finding just the place you want. In The Examiner's Classified "Homes for Rent" columns are many desirable vacancies, segregated into city district groups.

EXAMINER
Classified ADS

Patriotic Pilgrimage for Regional 'Flag' Contest Winners--Page 1, Part 2

NED DOHENY MURDERED. On the very day in February 1929 that the Capistrano Beach Club's ballroom ceiling was being hand-painted, Edward Doheny Jr. was murdered in his Beverly Hills home, the famous Greystone mansion. (Courtesy Don Sloper.)

47

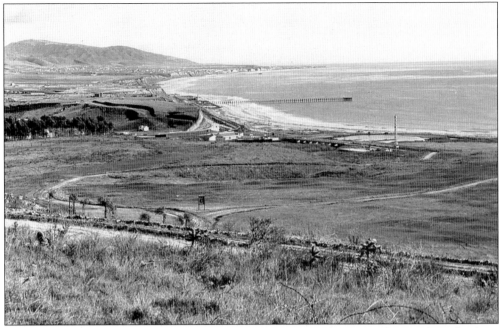

SEASIDE SERENITY. Before the highway came through in 1929, the unpaved route along the shore ended on each side of San Juan Creek. Roads along both sides of the creek ran inland, meeting in San Juan Capistrano. Here construction was underway to connect Dana Point and Capistrano Beach at the coast. The Capistrano Beach pier and the landmark Richfield Tower in Dana Point are visible here. Both structures became sea and land icons on navigational charts and maps.

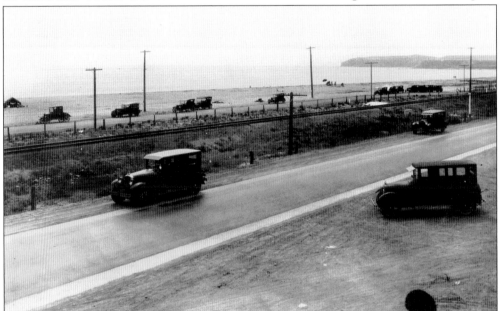

BEACH BUGGIES. The paving of the highway below the palisades brought heightened motorcar traffic. Many drivers took a scenic detour along the strand that would become county and state beach parks. In between the sand and the highway ran the railroad tracks, which still carry Amtrak Surfliner trains along this scenic route.

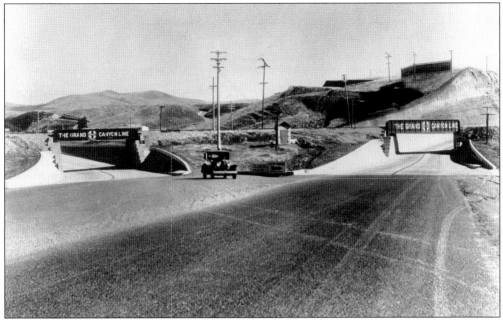

COAST CONNECTIONS. Tracts in Capistrano Beach and Dana Point were finally connected by a highway bridge over San Juan Creek in 1929. Two railroad bridges enabled trains to cross above the new road on Santa Fe's Grand Canyon Line. The highway along Capistrano Beach paralleled the tracks, each roadbed requiring severe cutback of the cliffsides. These cuts, seen at far right, enhanced the cliffs' instability, leading to road- and track-closing landslides in recent decades.

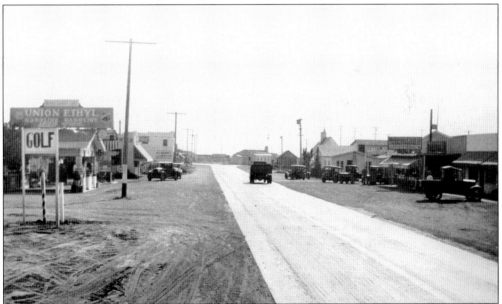

DOWNTOWN SERRA, C. 1930. While the two grand residential communities were arising on higher ground to the north and south of it, downtown Serra provided the necessities of life and business, unless one wanted to venture further into San Juan Capistrano, three miles inland. Union Oil had a station that would last for years, as did many mom-and-pop ventures like Lucy's Café and Marie's Restaurant and Cottages. (Courtesy Orange County Archives.)

HISTORIC POSTS AND PINES. The Capistrano Beach development on the palisades featured these ornamental streetlights throughout the community. Some still stand on Estrella Mall, stretching from Camino Capistrano at the Doheny Mansion. Palms and pines were the landmark trees of the community. Las Palmas is still a major street, and Pines Park is a much loved attraction. (Photograph by the author.)

Five

SAN JUAN POINT– DANA POINT

Your presentation of Dana Point to the Great American Public is very convincing and is very constructive and attractive. If work like this doesn't sell that property, it can't be sold.

—Mack Sennett, 1927
Actor, director, and producer of silent movies
and investor in the Dana Point Syndicate

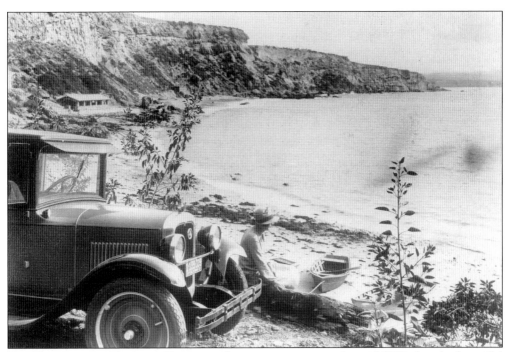

THE LOOK OF THE FUTURE. Visitors to this romantic spot in the mid-1920s found a beautiful coast yet to be tamed for recreation. Boating was simple, a picnic shelter made of native rocks was the only structure in sight, and flowering tobacco was among the few plants that had adapted to the salty shore.

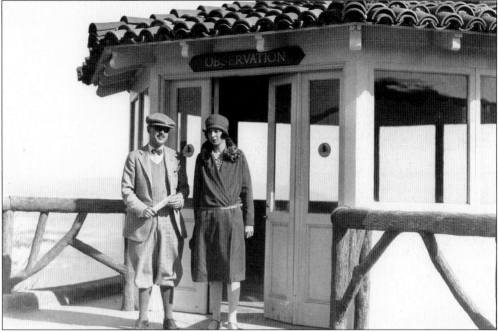

FIRST BLUFF-TOP DEVELOPMENT. In 1923, a Laguna Beach real estate syndicate purchased 900 acres, planning to transform the endless lima-bean fields of San Juan Point into an "exclusive residential and rest resort." Leading the enterprise was realtor Anna Walters, pictured with her husband, R. F. Walker, at the observation gazebo she designed at the bluff's edge of Street of the Blue Lantern. Walters is credited with naming streets for the colors of ships' lanterns: Green, Blue, Ruby, Amber, Violet, and Golden.

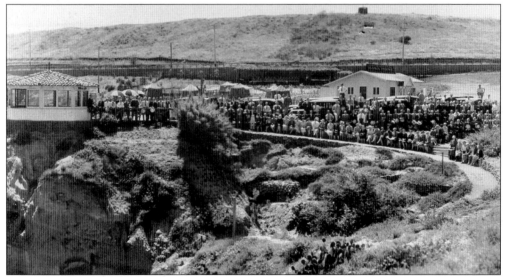

GATHERING AT THE GAZEBO. This lookout continued to play a role promoting lot sales throughout the 1920s. Between it and the sales office are the deal-closing tents. A winding path took adventurous hikers down to the beach below, along a trail bordered by prickly pear cactus. Early sailors who climbed these cliffs to retrieve cowhides mentioned this spiky plant in their journals. Today the restored gazebo provides a prime view of Dana Point Harbor.

STAIRWAY TO THE SAND. "Scenic serpentine walks from the heights to the beach" is how the advertisements explained the dirt paths outlined with walls made of the local beach rock. Concrete steps helped walkers in the steepest spots along the winding boulder-bordered trail. Six "lovers' landings" offered covered benches for momentary rest and a view of the coastal scene.

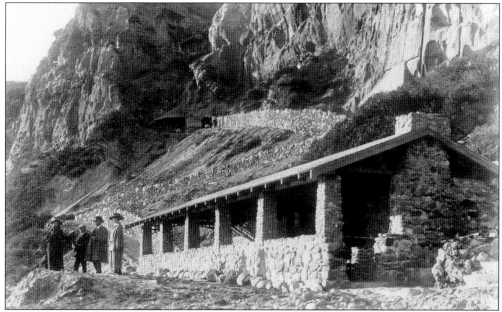

ROCK-SOLID SCENIC INN. This picnic shelter was a work of rock at the end of the trail, which was called Dana's Trail because it simulated the route of cowhides tossed from the cliffs during 1830s trading-ship visits. Ed and George Seeman hauled the rocks up from the shore in gunnysacks and hand-set them. By the time more serious rock work would create the harbor breakwaters in the 1960s, the Scenic Inn would be just a memory, broken apart by sea swells.

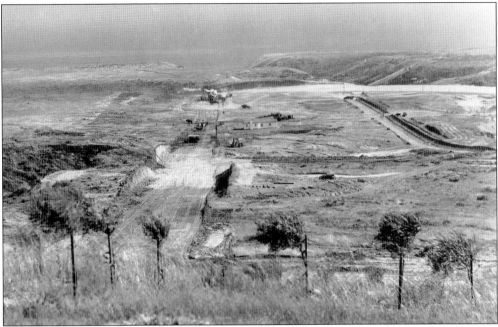

LET THE TOWN BEGIN. Grading of the hilly terrain was a challenge in cutting through the initial streets of San Juan Point in 1923. Without a coastal road or reliable source of fresh water, the determined group daringly constructed the first buildings. The scene was set in a literal desert oasis, surrounded by gullies and one row of staked hillside trees optimistically planted for future shade.

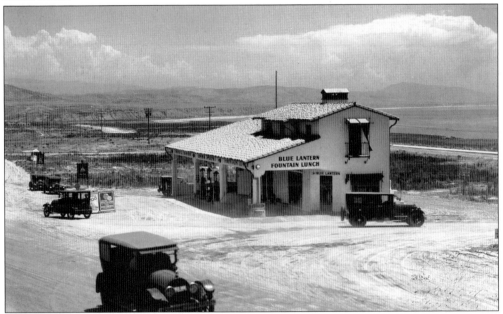

FIRST COMMERCIAL BUSINESS. Anticipating where the future coast highway would cross this new Street of the Blue Lantern, Anna Walters built her own business: Blue Lantern Fountain Lunch and Service Station. It was wisely meant to satisfy the two major needs of anyone venturing down the dirt road that lay before it. The observation gazebo was erected to the right of this photograph.

HIGHLIGHTING THE LANTERNS.
A volunteer model points out the
distinctive copper ship's lanterns that
would light the entire community,
powered by underground electric
wiring. This lamp stood outside the
tract office that would serve a second
try at development before the decade
was out. That early building is still
a landmark at the northwest entry
to the town center, where the road
divides into Del Prado and Pacific
Coast Highway.

HEADING UP THE HIGHWAY.
Looking northwest with the Dana
Point headlands in the background,
the Blue Lantern Fountain Lunch
displays sandwich signs promoting
such necessities as Shell Oil and urging
passersby to "Read—Dana Point," with
a sketch of the book *Two Years Before
the Mast*. Thus began the romance
with Richard Henry Dana's classic that
would continue indefinitely within the
city named for him.

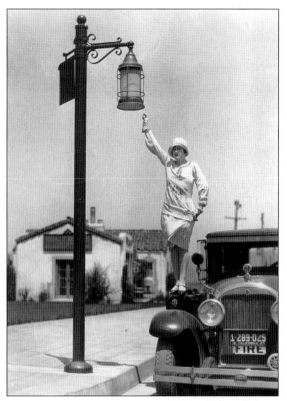

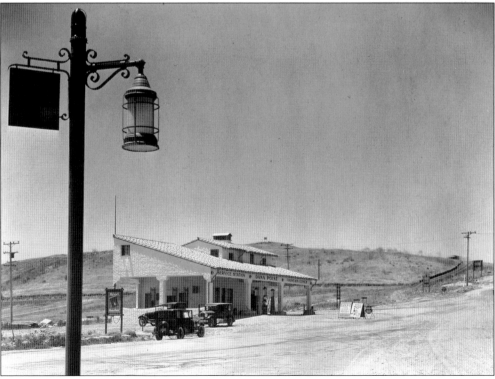

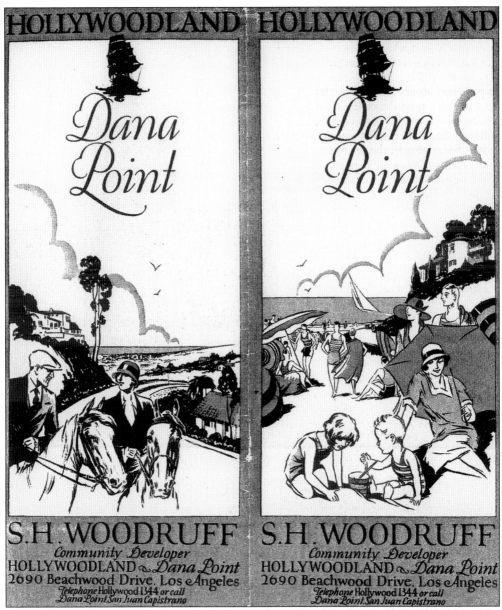

PROMOTING DANA POINT, 1927. "Dana Point is the logical answer to a demand for a really fine and dominant seashore city on California's southern coast. . . . Here are beautiful palisades, golden beaches, a charming stillwater bay, splendid soil, an incomparable climate and splendid water supply." Sidney H. Woodruff turned to development of Dana Point after his success with Hollywoodland. Its promotional hillside sign that he erected would lose its last syllable with time, while gaining lasting worldwide fame as the icon for Hollywood itself.

THE LURE OF SALT WATER. This sign on Street of the Blue Lantern beckoned to visitors: "Come on in, the water's fine—Dana Point." It is topped by an iron cutout of Dana's ship, *Pilgrim*. Roaring Twenties visitors eyed the view from the observation gazebo. The beautiful salt water, stillwater bay had been little noticed before. Swimming in the sea was a novelty of the 1920s, when swimsuits, like dresses, were shortened and sleeves disappeared altogether.

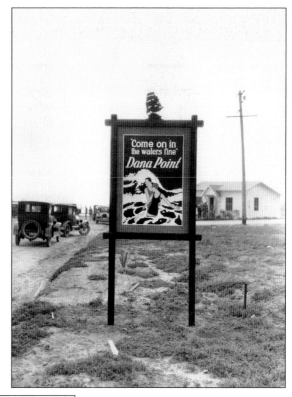

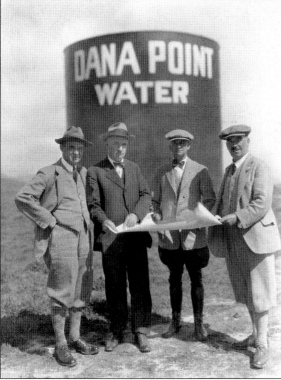

THE LURE OF FRESH WATER. Was Dana Point's first hilltop water tower really full, as S. H. Woodruff, second from left, poses with his managers there? The scarcity of local water saw the Dana Point Syndicate join with Doheny's neighboring Capistrano Beach Company to develop water-bearing lands along San Juan Creek. Their San Juan Water Company predicted local wells could supply 125,000 residents. History showed it couldn't.

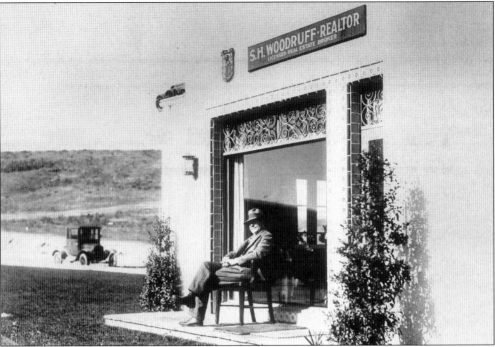

Woodruff Awaits Customers, 1927. S. H. Woodruff, licensed real estate broker, waits for customers outside his wrought iron– and tile-decorated office at Coast Highway and Del Prado. In addition to acquiring the San Juan Point property that had reached foreclosure after only three months, Woodruff's syndicate purchased nearly 1,400 more acres to the southeast. And so within it, more lantern streets came to be: Silver, Copper, and Crystal.

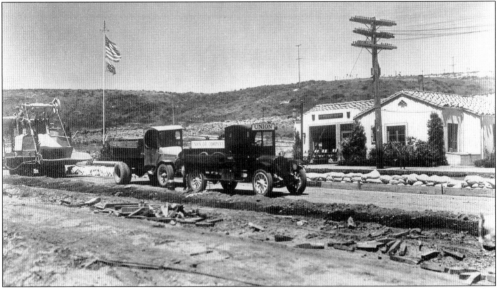

Grading Equipment Refueled. Prominent throughout the upcoming Dana Point development were trucks of the Union Oil Company, ready to refuel the heavy equipment that had the task of constructing streets within the tract. The Woodruff sales office is seen at right. A prominent flagpole there flew both the American and Dana Point flags.

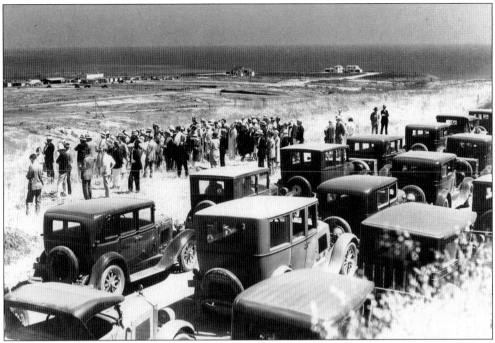

GETTING TO THE POINT. As the "city-in-the-building on California's glorious south coast" continued, group tours were conducted for on-site viewing. Woodruff's prose disguised the lack of direct avenues of transportation by pointing out that "Dana Point is unspoiled by railroads or highways along its ocean frontage," and "the topography of the land slopes to the sea, giving the entire subdivision an excellent view of the ocean."

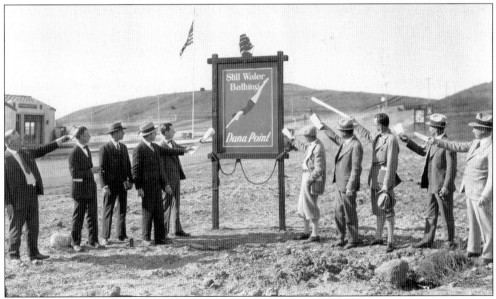

POINTING OUT THE SCENE. If words and views were not enough, the sales staff brought home the positive point of "Still Water Bathing" at Dana Point, where a sheltered yacht harbor was planned to include breakwaters, moorings, a yacht club, and a swimming beach. All these amenities did come true in modern times, but the only one built in the 1920s was a fishing and pleasure pier.

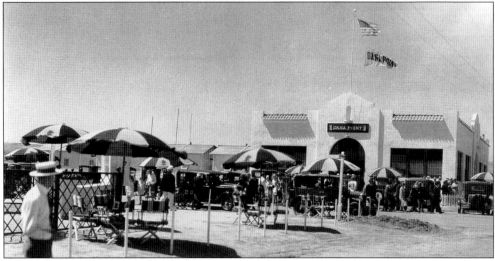

ENTERTAINING CUSTOMERS. The auditorium, constructed by the earlier Walters group, became the "community center" where prospective lot buyers were entertained. Dinners came with emotional, promotional talks about the superb investment potential of Dana Point property, even beyond the exciting lifestyle it would afford. This building has continued to play a landmark role, first as a pottery factory, now a restaurant.

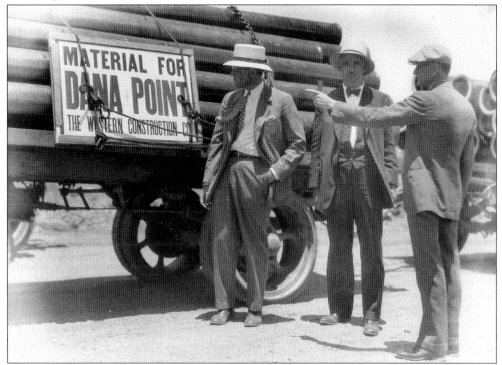

IT PAYS TO ADVERTISE. The Western Construction Company of Los Angeles became the official builder of the new town, and its trucks carried signs disclosing where their load was headed. The underground electrical system, already begun, was expanded throughout the new acreage. Sewers, telephone lines, concrete streets, and sidewalks were completed while the first houses were constructed.

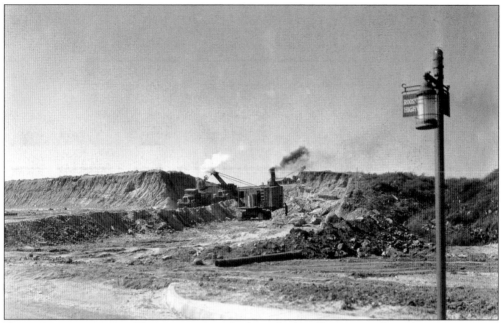

CLIFF CUTTING ON THE HIGHWAY, 1928. Curbs and sidewalks were in place along yet unpaved Roosevelt Coast Highway, whose coming was being announced by this distinctive lantern streetlight. Steam shovels cut back the earth, filling dump trucks to create pads for business buildings. Mule teams pulled the graders that leveled the roadbed for the highway the following year.

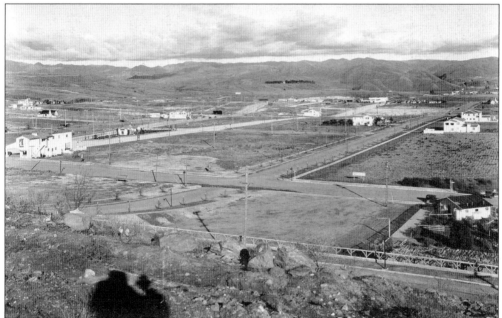

TOWN TAKES SHAPE, 1928. Newly completed Street of the Blue Lantern and Santa Clara Avenue stretch out through town, with Del Prado visible beyond. Roosevelt Highway was yet to be paved. Various businesses and homes were dispersed throughout the downtown of this seaside city. The fence along Street of the Green Lantern (in foreground) was made of welded pipes covered with mesh and concrete to resemble tree branches.

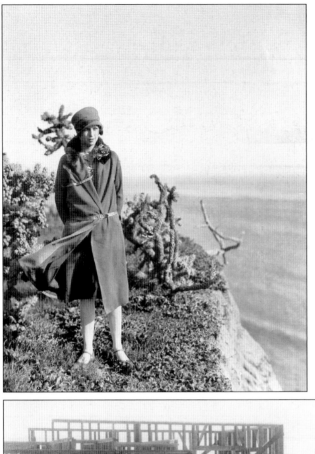

FIRST DEVELOPER AWAITS HER HOME. Anna Walters, of the original San Juan Point tract, stayed on with the Woodruff development. The nautical street names were expanded, and the original public buildings—the gazebo and the auditorium—became focal points in the renewed tract. Here Walters looks out to sea near the site of her own home on Street of the Green Lantern beside a native species of spiny cactus.

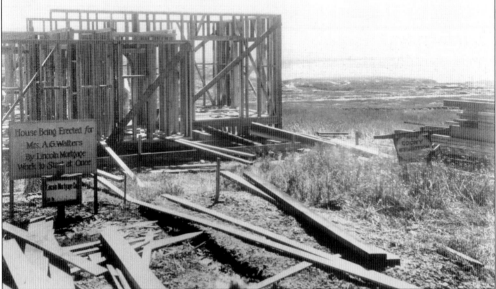

WALTERS'S HOME IS FRAMED. At this oceanview site on Street of the Green Lantern, the 1928 sign reads: "House Being Erected for Mrs. A. G. Walters by Lincoln Mortgage. Work to Start at Once." The curve of the Capistrano Bay coast beyond remained as yet undeveloped. Walters's home would be within walking distance of both her Blue Lantern Fountain Lunch and Service Station and her observation gazebo.

ONE OF THE FIRST HOMES. Finishing touches like mortar for tile required small construction equipment at this site on Granada Drive. Lincoln Mortgage Company financed 13 of the first homes, while some lot owners sought their own financing and others held their bare parcels for investment. Today streets with restored 1920s homes also include Santa Clara Avenue, El Camino Capistrano, Chula Vista Avenue, Street of the Blue Lantern, and El Encanto Avenue.

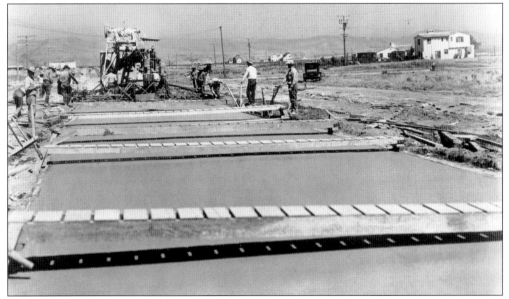

SANTA CLARA EVOLVES. Laying concrete along Santa Clara Avenue required specialized equipment in the 1920s as well as a team of specialists. The streets within the development were built by Western Construction Company. Many of those concrete streets remain, as well as sidewalks with stampings indicating the constructing company and the date they were poured.

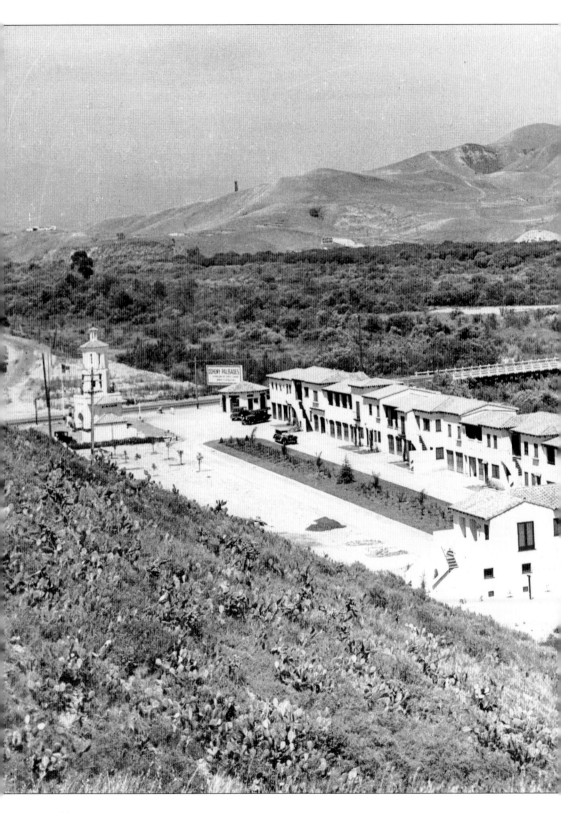

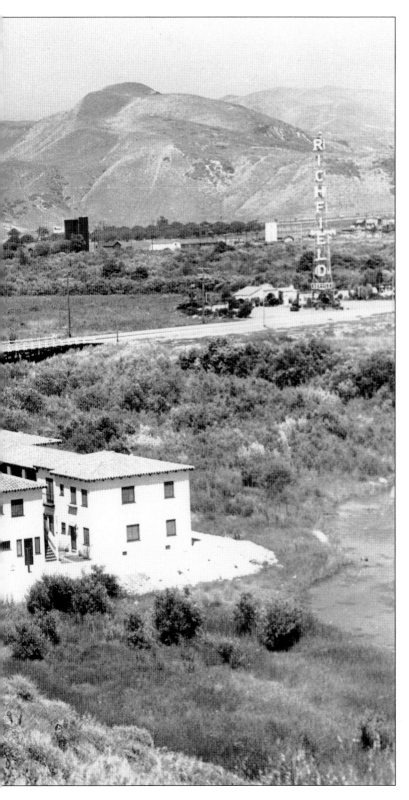

BIRD'S-EYE VIEW OF SWEEPING SETTING, C. 1930. This elevated angle of the budding community shows a foreground of cactus, then dense growth filling San Juan Creek, even under the new highway bridge at center. Foothills of the Santa Ana Mountains form the backdrop. Across the highway at right are the 125-foot-high Richfield Tower and its service station. One of the first of three dozen such towers erected 50 miles apart along the coast by Atlantic Richfield Company, Dana Point's would serve as a lighted navigational beacon for nearly half a century. The two black Santa Fe Railroad water towers across the Capistrano Valley depended on local wells to keep the engines' boilers full. The road leading inland at far left is the old hide road, then McKinley Avenue, now Del Obispo Street.

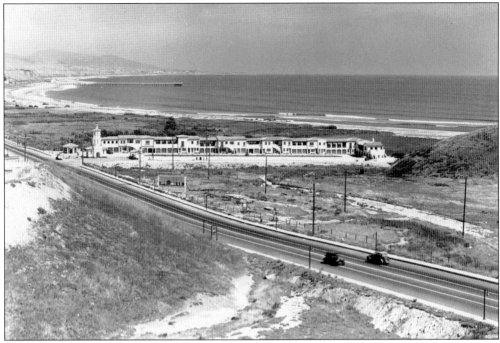

PARALLEL POINTS OF VIEW. Dana Point's first motel, the Dana Villa, was constructed with an eye to luring real estate customers to stay a second day before the long trip on unworthy roads back to their homes. Its 29 units and café stretched from the highway nearly to the shore. In this *c.* 1930 photograph, the Villa parallels the line of the Capistrano Beach pier. The land beyond the motel would become Doheny State Beach. Traffic on the new highway was light.

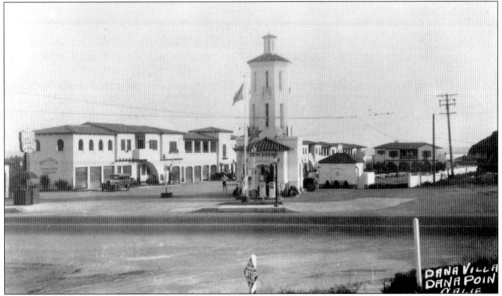

UNION OIL STATION. This front view of the Dana Villa shows that Union Oil Company maintained a service station there as well as fueling the construction equipment of the tract. The Dana Villa sign offers "Completely Furnished Motel Apartments." There was a garage for nearly every unit.

66

STILL ROMANTIC COVE, 1929. Except for the fishing pier added by the developers, Dana Cove was little changed. Two of the fisher families' tarpaper shacks had been reinforced, restored, and painted to serve as cottages for visiting fishermen attracted by sales promotions of the development. Small pocket beaches, described nearly a century before by namesake Dana, can be seen at the base of the bluffs.

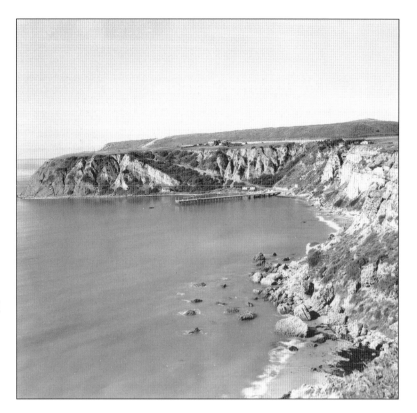

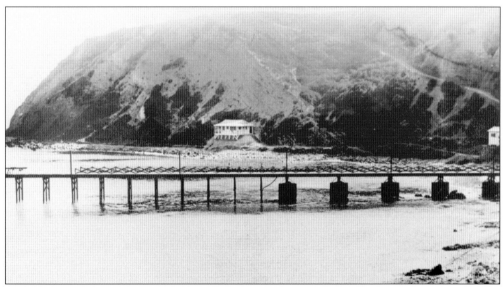

PRIME VIEW CABIN. The Woodruff tract's sales manager, George Hannan, had this large cabin built for his family west of the unpaved cove road. Children living there had the cove as their playground. The fishing and pleasure pier Woodruff promised, and built, stretches across the cove. One of the fishing cabins can be seen at far right.

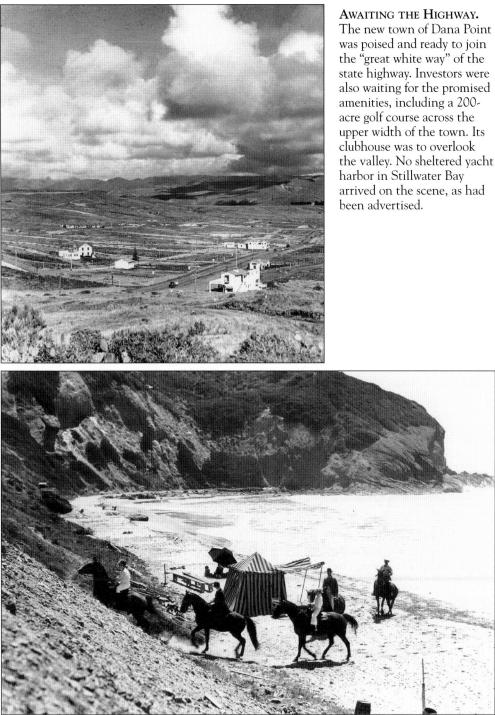

AWAITING THE HIGHWAY. The new town of Dana Point was poised and ready to join the "great white way" of the state highway. Investors were also waiting for the promised amenities, including a 200-acre golf course across the upper width of the town. Its clubhouse was to overlook the valley. No sheltered yacht harbor in Stillwater Bay arrived on the scene, as had been advertised.

DANA STRAND BEACH. The sandy beach north of the headlands was the prime place for picnics and barbecues, swimming, and bodysurfing during the life of the Woodruff project. His plan included polo fields, bridle trails, and a riding ring, so horses were paraded along the beach and up the trails, a preview of coming attractions that never developed in Dana Point.

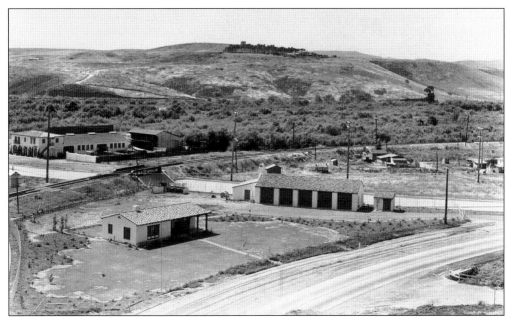

NEW HIGHWAY'S IMPACT. South of the tract, the new highway would pass the buildings of the State Division of Highways. Across the road was the Capistrano Beach Building Materials Company. It advertised that it carried "everything imaginable in the building line from lumber to nails." Its owners expected great sales when "the new highway raised land values." The front building was later moved and is still standing in the vicinity.

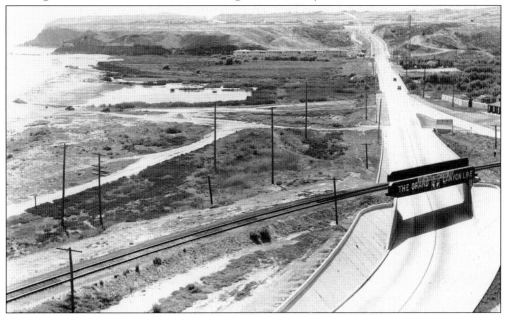

GREAT WHITE HIGHWAY. Just months before the stock market crash of 1929, the state's Roosevelt Coast Highway was completed through Dana Point. Gov. C. C. Young shoveled away the last earth barrier with a golden engraved shovel and also pulled a switch to light the ornamental lantern streetlamps. The Woodruff Syndicate, with the new Orange County Coast Association, hosted a celebration in the auditorium.

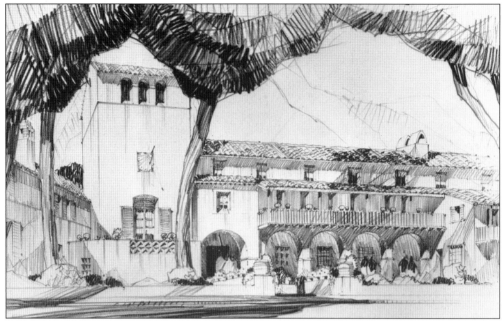

THE DREAM HOTEL. While an even larger hotel was planned for the headlands, the centerpiece of "downtown" Dana Point was to be this Spanish-style hotel perched dramatically on the cliff. It was to provide an expansive dining room seating 1,250, though only 100 large hotel rooms and on-site parking for only 100 automobiles. There was to be a separate children's dining room. The hotel rate was to start at $10 a night, including two meals.

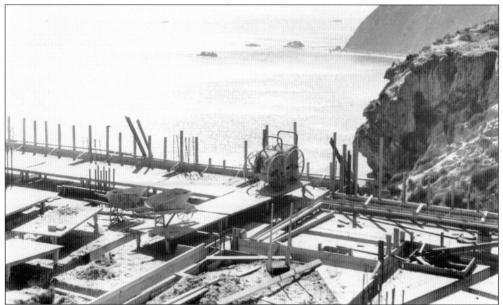

HOTEL CONSTRUCTION BEGINS. The Dana Inn ground-breaking was held on January 30, 1930, with a guest list of prominent Southern Californians, including members of the syndicate, bankers, and press. Three stories of hand-mixed concrete (before ready-mix) were completed. A 135-foot-deep elevator shaft was dug through the cliffs down to the beach. Dana Inn was to fill the need for a high-class hotel halfway between Los Angeles and San Diego.

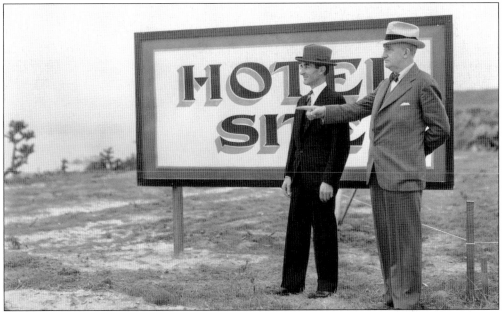

X MARKS THE SPOT. Proud developer S. H. Woodruff, at right, points out the hotel site to the architect, Charles A. Hunter. He called it "California Renaissance" style. The bond prospectus to finance Dana Inn said it would offer "splendid accommodations for banquets, conventions, private parties, as well as the individual's needs." It was to combine the beauty of an early California hacienda with ultra-modern hotel facilities.

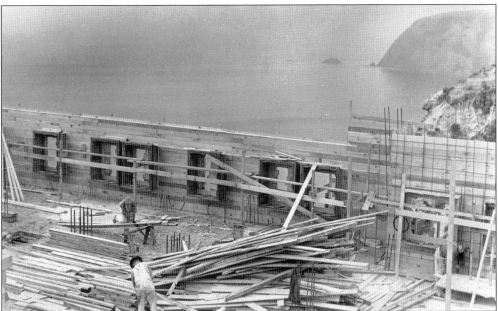

HOTEL FRAMING TAKES SHAPE. Initial framing around the hotel's bold arches changed the contour of the coastal canyon where it was being built. The unfinished profile would dominate the dream project, begun in probably the worst year it could have been planned. The greatest financial crash in the nation's history, in late 1929, quelled construction of the hotel and the community with so much promise.

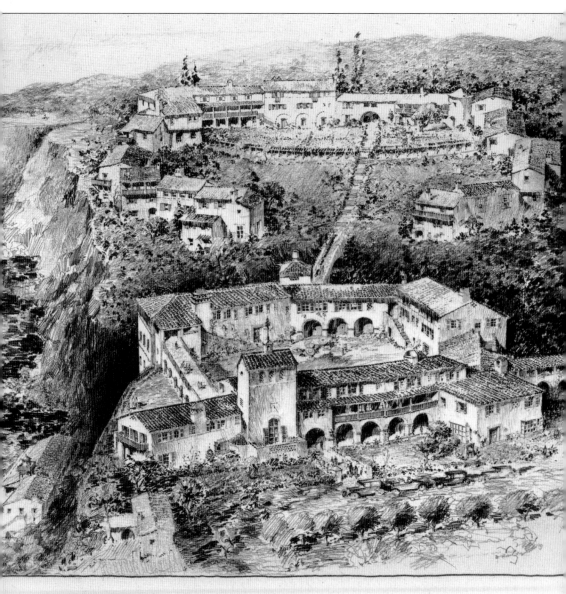

DANA POINT INN
DANA POINT · · · · CALIFORNIA

DANA POINT INN. If this preview architect's drawing of the magnificent Dana Inn overlooking Stillwater Bay had been completed, Dana Point would no doubt have become a resort port half a century before it actually did become a port in the 1970s and a resort city in the 1990s. A beach club similar in style to the one built in Capistrano Beach is sketched on the shore below the hotel.

Six

DEPRESSION AND WAR YEARS

Everybody bought lots, but nobody built houses on them was the story of the 1930s along the cliffs of Capistrano Bay. Faith, hope and scenery carried the decade off!

—Doris Walker
Home Port for Romance

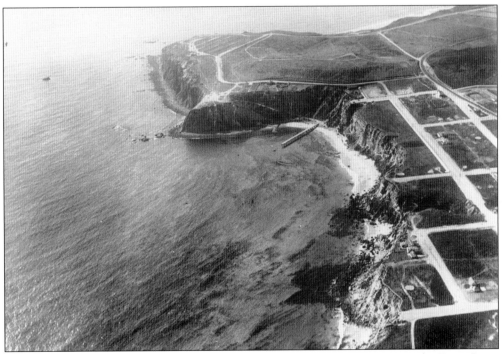

STREETS FOR SALE. The stock market crash of late 1929 seemed far away to the Dana Point Syndicate, which began construction of its grand hotel in January 1930. However, S. H. Woodruff and his associates soon found themselves the mortgaged owners of sturdy concrete streets, innovative underground utilities, and bare building pads. Their hoped-for buyer/builders were more concerned with investing in groceries.

73

Too Much Too Soon. Dana Point held promise of becoming another successful Hollywoodland—except for its timing. Instead of colorfully landscaped streets to match the lantern names, only cactus and native scrub grew around the dramatic enclave of white houses with red-tiled roofs in the 1930s. The promising water tower, a tiny speck in the hills, became a sign of failure; an ample supply of fresh water had not materialized.

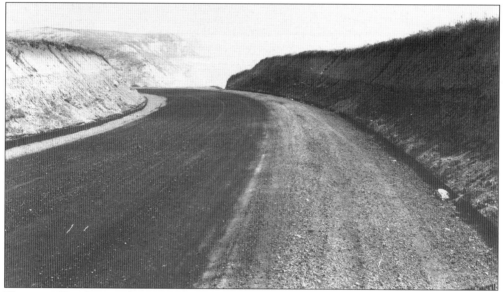

Highway Too Late. The promised paving of Roosevelt Coast Highway through south Orange County had moved through Laguna Beach in 1926. However, it didn't reach Dana Point until 1929. Here it is being built, approaching the curve down to Salt Creek. The new road carried little leisure traffic as the 1930s moved along. Few families had the resources to spend on idle driving, let alone purchasing property or building a home on the county's frontier.

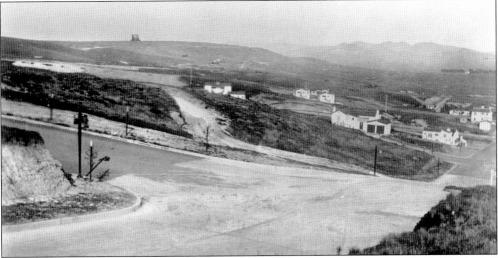

SIGNS OF BAD TIMES. This late-1930s photograph caught the intersection of La Cresta Drive and Street of the Blue Lantern in disarray. The ornamental lantern streetlamps still stood, but the streets showed signs of neglect. Though remnants of unimproved lots rimmed them then, most of the sturdy buildings pictured here have lived into the present era.

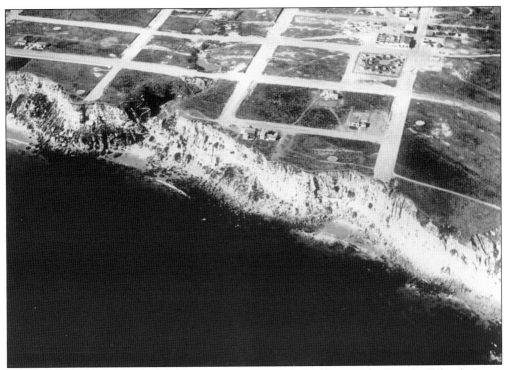

FEW AND FAR BETWEEN. In this 1930s aerial photograph, buildings of the Woodruff development can still be seen. At upper right is the auditorium, where sales promotion gatherings had been held. Around it were groups of cabins to accommodate sales closings. Below the bluffs, high tides and sea swells had washed away the rock work, leaving only small pocket beaches, and those only at low tide.

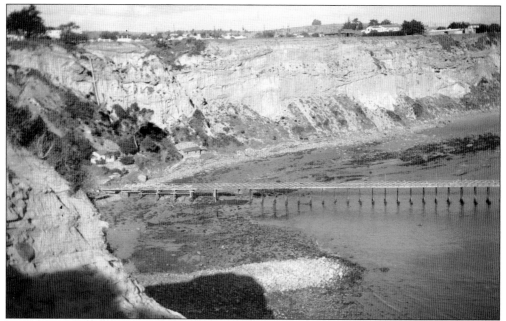

DANA COVE SURVIVED. The improved cove cottages continued to hold dwellers, because the fish didn't feel the effects of the Great Depression. In fact, the 1930s produced some of the best fishing in local history. The sturdy fishing pier still offered a free walkway into the open sea. However, the Scenic Inn had washed away during the down decade, with no maintenance after the tract above was sold for taxes. It became just a pile of historic rocks.

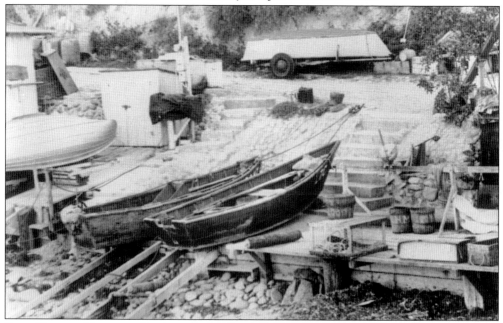

BARE BOTTOM BOATING. Rowboats on trailers still eased their way across the sand and climbed the cove stairs on wooden ramps. This 1938 photograph shows how supplies were stored by very simple means along the concrete steps that had been laid for the well-heeled visitors who walked them leisurely during the Roaring Twenties.

TEARS FOR WHAT MIGHT HAVE BEEN. The unfinished Dana Inn framework disappeared, board by board, over the lean years. It became firewood for unidentified individuals who also pilfered the copper streetlamps for their salvage value. Runoff rain water slid from the streets and down the stone stairway, shedding tears of unfulfillment for the hotel, still evidenced here in the 1960s. (Photograph by the author.)

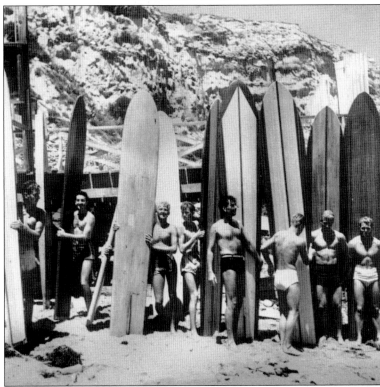

KILLER DANA STIRS SURFING. The lure of Dana Cove climaxed with the arrival of spectacular surf breaks. In this 1939 photograph, the greats of big-board surfing gathered to challenge breaks up to 30 feet high. Stellar surfers, posed from the center to the far right, like "Nelly Bly" Brignell, "Peanuts" Larson, Johnnie Waters, and Yan Egassa, congregate with younger upcoming surfers at left. The boards were more than 10 feet long and 100 pounds heavy.

77

DOHENY PARK CREATED. In 1931, the Doheny family donated 41 acres of the Capistrano Beach project as a tribute to their murdered son, its developer. The highlight of that decade was construction by the federal Civilian Conservation Corps, which made adobe blocks on-site and gathered beach boulders to build park walls, arches, ramadas, and buildings. Doheny Beach Park went on to national fame. Its main entrance, seen here, was on Roosevelt Coast Highway.

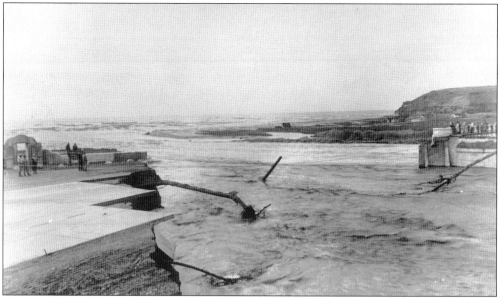

STORMY SETBACK. During March 1938, two weeks of heavy rain caused flooding over much of Orange County. Fast-moving water destroyed neighborhoods on its way to sea. In Dana Point, the highway bridge over San Juan Creek was severed from the land, filling Doheny Beach with hunks of concrete, twisted steel pilings, and uprooted orange trees. However, the park's new adobe entrance arch, seen at far left, stood its ground. Lumber from the building company across the highway that floated out to sea was soon turned into lobster traps.

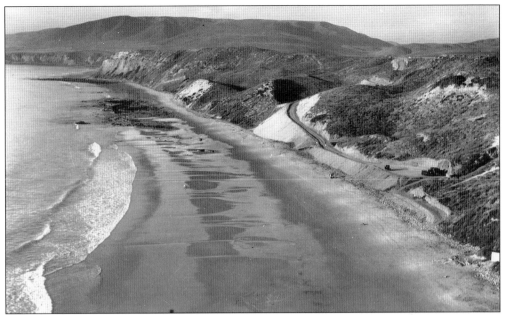

DANA STRAND SHORELINE, C. 1930. This narrow, winding road from highway (upper right) to seashore ended at a tiny parking lot. It continued to challenge beachgoers—those who knew of its existence. Before becoming the Strand at Headlands, a luxury private community in the 21st century, this stretch of coast would host a private trailer park.

FLOWER FIELDS BLOOM. Developer S. H. Woodruff, attempting to turn around his sagging property investment in 1935, disclosed a grand plan to grow flowers along this coast. He harbored the idea of building factories to extract the essential oils, produce perfumes from "the smiling blossoms," bottle "the scents of California," and uncork them around the world. Instead, by 1939, he saw the syndicate's holdings auctioned away to satisfy accumulated property taxes.

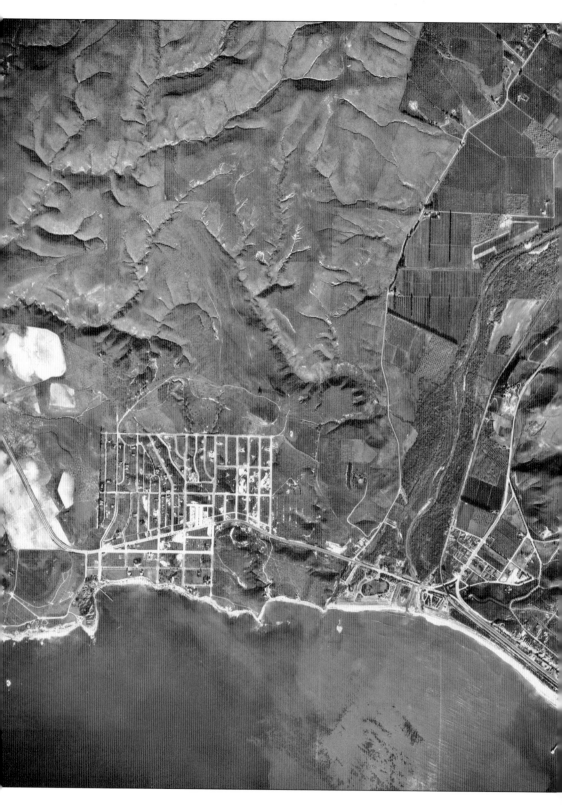

80

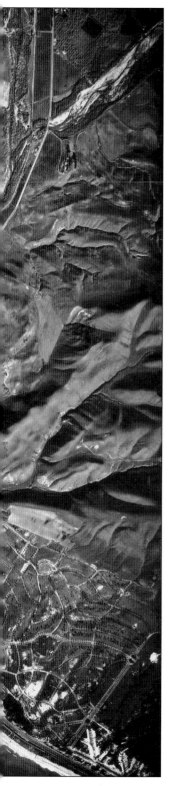

DANA POINT AND CAPISTRANO BEACH MIDWAY IN HISTORY.
For Dana Point, the 1940s were the halfway time between the
seminal building of blufftop villages and the start of construction
of Dana Point Harbor in the 1960s. At the end of World War
II, the coast from the Dana Point headlands to beyond the
Capistrano Beach pier had not grown appreciably. This 1946
aerial photograph shows that Dana Point was still within the
original square boundaries of the 1920s. In contrast, a romantic
legend says that Capistrano Beach of the 1920s was designed
to simulate a rose: the winding streets lined with palm trees
becoming the stems and branches, with the red-tiled roofs
representing the blooms.

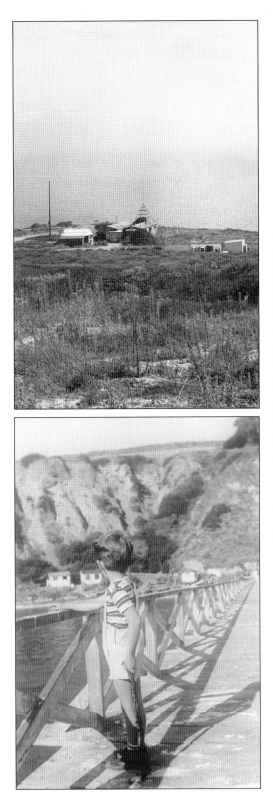

WORLD WAR II. Residents living in Dana Cove, sensing nothing new was happening on the bluffs above them, suddenly saw something unusual appear during 1941. The roof of one nondescript house had sprouted a strange tower above the headlands. With the arrival of World War II in the Pacific, this coast was declared a vulnerable area. The new structure was a LORAN (Long Range Aid to Navigation) transmitter installed by the U.S. Coast Guard. Although it appeared frail, it loomed like a lighthouse to cove residents, including young Gary Guthrie, who played out the global events with his toy rifle. There were rumors of a large navy anchorage developing here and that Japanese submarines were lurking in the offshore waters. The area's Japanese Americans were taken to government internment camps. Residents along Orange County's coastline had to dim their lights and participate in air-raid drills. Yachtsmen in new Newport Harbor were forbidden to venture outside its breakwaters.

Seven

FARMS TO FREEWAYS AND TRACTS

This is an era of town building in Southern California, and it is proper that it should be so, for the people are coming to us from the East and from the North and from beyond the sea. . . . For the great multitude whose faces are turned with longing eyes toward this summer land, and who will want homes among us, we must provide places.

—Pasadena Daily Union, 1887

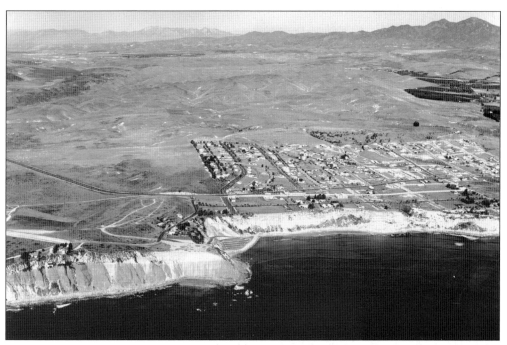

POST-WAR AND PRE-FREEWAY TOWN. The old Dana Point had ventured east only to Selva Road and north only to Street of the Green Lantern. The Dana Point that erupted in the 1950s would extend in all directions except seaward. That growth would come in the next decades. Foothills of the Santa Ana Mountains and farmlands of the Capistrano Valley framed the coastal community when this aerial view was captured in 1957. (Pacific Air Industries photograph.)

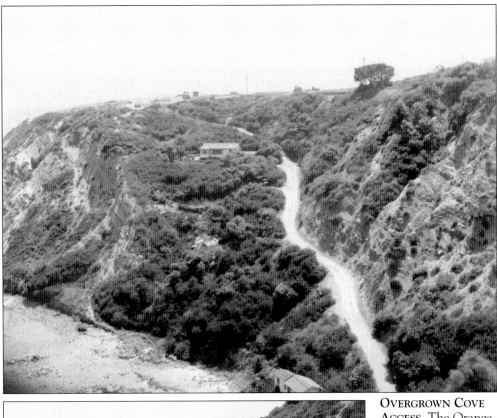

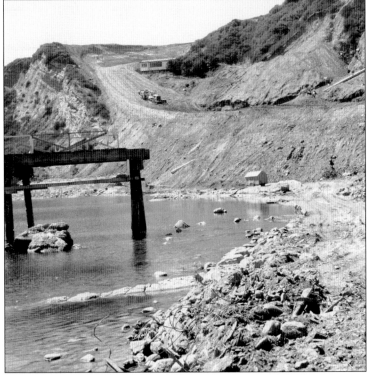

OVERGROWN COVE ACCESS. The Orange County Harbor District began compiling engineering data in the 1950s for the advent of a harbor at Dana Point. In 1956, the county designated Dana Cove as a recreation area. Work began to turn steep Cove Road into a serious entry connecting with Pacific Coast Highway. The old caretaker's cottage on the hill was preserved to serve another era. The 1920s fishing pier, at lower left, was cut away and demolished. (Both Orange County Archives.)

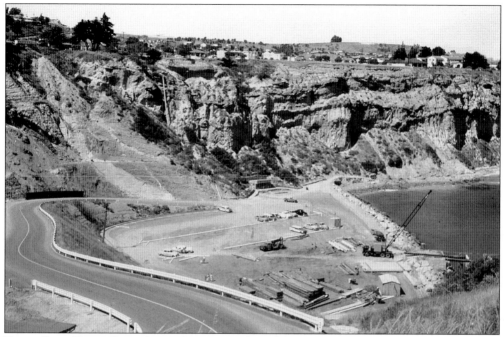

DANA COVE PARK. Once the road was strengthened, heavy equipment could meander down to fill some sea bottom, creating a parking lot and picnic area. It was hailed as the first unit of the proposed small-craft harbor. Proposals starting in the late 1940s suggested that Capistrano Bay was the ideal location for a harbor of refuge. In 1957, a new 300-foot fishing pier replaced the 1920s model. (Courtesy Orange County Archives.)

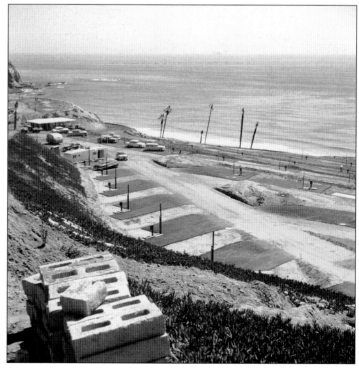

DANA STRAND TRAILER PARK. In the mid-1950s, on this northern edge of the headlands, pads were graded for the weekend trailers of members and guests. The Strand Beach and Tennis Club offered a pool, tennis courts, clubhouse, and a private beach. In 1988, the club was closed. In 2006, this site became the Strand at Headlands, where luxury lots have sold for an average of more than $5 million. (Courtesy Orange County Archives.)

SCRAMBLED SIGNS OF THE TIMES. The San Diego Freeway opened through the south coast in 1958, but it took a while longer for on-ramps and off-ramps and signs to be put in place. At the Capistrano Beach on-ramp, plans were laid for the freeway to connect with yet another freeway running along the coast. Public outcries quelled that project, but it left this unfinished section with an especially complicated intersection. (Photograph by the author.)

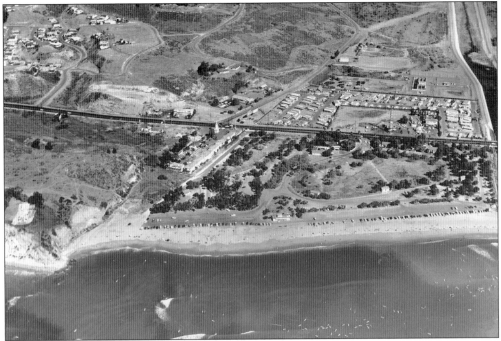

STATE BEACH AND HIGHWAY, 1965. By this time, Doheny Beach Park was well landscaped. Delighted visitors lined its shore when parking was allowed along the beach. A mobile home park had come to surround the Atlantic Richfield tower and service station on Pacific Coast Highway. The Dana Villa (at center) continued to be the town's best-known hotel accommodation, and its restaurant was popular to those traveling the San Diego Freeway (I-5).

STILL ROMANTIC SPOT. The cliffs and coves of Dana Point in their unchanged condition continued to draw artists through the decades to capture their color and configurations. Dana Point had been the first drawing card for artists in the late 1800s, but because there were no hotel accommodations, the artists' colony grew at Laguna Beach instead. (Photograph by the author.)

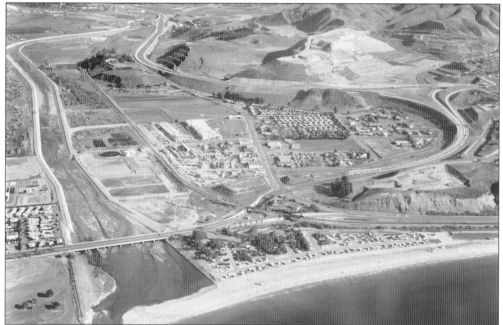

FREEWAY MEETS CAPISTRANO BEACH. South of San Juan Creek, the freeway/highway connection is visible, as is the full house at Doheny State Beach's campground. Inland beyond the freeway, construction pads for various housing tracts are visible, a sign of the changes in store for this community. Commercial buildings in Capistrano Beach and the school district headquarters and bus yard are visible beside the freeway. (Courtesy Smetona Photo.)

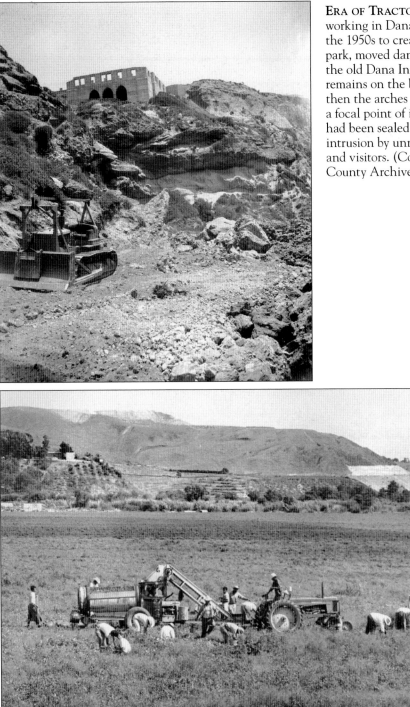

ERA OF TRACTORS. Bulldozers, working in Dana Cove during the 1950s to create a picnic park, moved dangerously near the old Dana Inn's "three-eyed" remains on the blufftop. By then the arches that were to be a focal point of its architecture had been sealed shut to prevent intrusion by unruly vandals and visitors. (Courtesy Orange County Archives.)

VALLEY FARMLANDS. On the outskirts of Dana Point, the Capistrano Valley was still the scene of farming in the 1960s. After the rancho area, when most of the land had been used for cattle grazing, vegetable crops became a local specialty. After tomatoes were picked by hand, a tractor pulled machinery that pulverized them for canning. (Photograph by the author.)

FARMS GIVE WAY TO TRACTS. Where Dana Point meets San Juan Capistrano on Del Obispo Street, farmlands stretched along the valley side of the road. In the mid-1960s, a backhoe excavates a section of Blue Fin Drive during construction of Dana Point's first housing tract, Dana Point Knolls, across from Remmers' Mission Bell Ranch. (Photograph by the author.)

REFINING ROCK USE. Homeowners within new tracts in Dana Point were challenged by adobe soil and an overabundance of rocks. Landscapers like Harry Otsubo and his crew extracted all these boulders from one backyard in 1963, replacing them with lawn. But in one corner, they traded the rocks for tiny river pebbles to create a young resident's anxiously awaited "rock box." (Photograph by the author.)

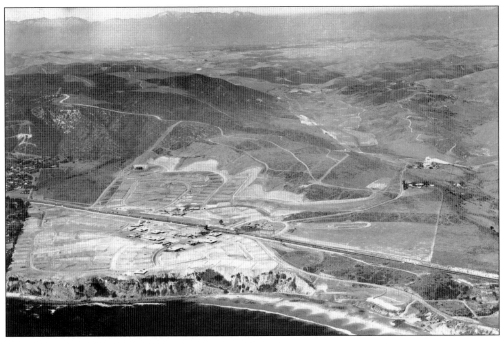

MONARCH BEACH BEGINS. The year 1961 brought the first development of the Monarch Beach section of Dana Point. It began with Monarch Bay and Sea Terrace by the Laguna Niguel Corporation, which acquired another 850 acres on the inland side of the highway, then sold it to Avco Community Developers in 1970 for development of Niguel Shores. This coastal area voted to become part of the new city of Dana Point in 1989.

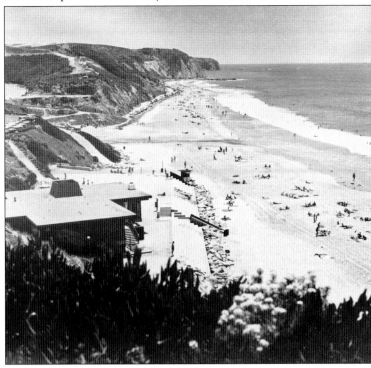

MONARCH BAY CLUB. First this was the beachfront community center for the private Monarch Bay development. The view extends down the coast to the Dana Point promontory. When the St. Regis Hotel was developed during the late 1990s, the Monarch Beach Golf Links and this club became affiliated with it, along with access to one hole taking golfers under the highway and onto an oceanfront green. A tram also runs between the hotel and beach club.

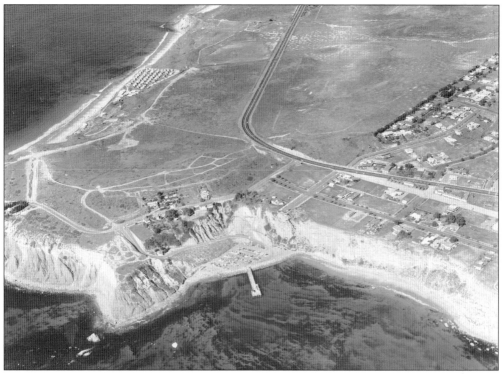

HEADLANDS AERIAL VIEW, C. 1960. Dana Point Headlands showed some building, some fencing, some trails, and Dana Strand Trailer Park (at left). Kite-flying contests, sailboat regattas, and cigarette-boat races became crowd-drawing events on the rest of the windy promontory. The new parking lot in Dana Cove Park was full beside the pier.

PREVIEWING COMING ATTRACTIONS. The Niguel Theater in Monarch Bay Plaza was owned by the family of actor James Cagney, an investor in the 1920s Dana Point Syndicate. Here, in the mid-1960s, it featured the movie *Becket*. Archbishop Becket was murdered, then became a saint. This theater flooded so often it was closed to public gatherings. It was eventually demolished to become part of an upscale shopping center. (Courtesy Orange County Archives.)

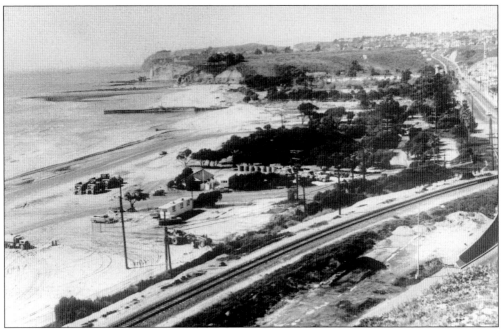

DOHENY BEACH EXPANSION. More land from the Santa Fe was acquired in 1942, and more was acquired from Union Oil in 1957. Then the Doheny Marine Life Refuge was created, and this park became the top revenue earner in the state system. In 1965, 800,000 cubic yards of sand were brought in from Camp Pendleton. By 1968, the popular park introduced advance reservations for camping. "Thor's Hammer" groins to help lessen sand erosion are visible at upper left.

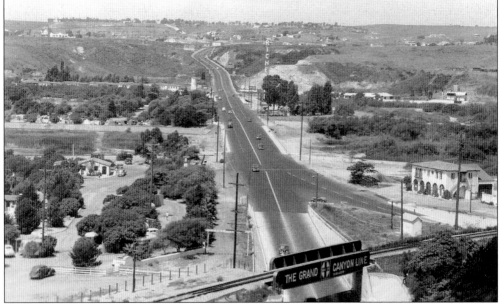

GREENERY OF THE 1950s. Looking northwest along the Pacific Coast Highway, several landmarks from the 1920s remained, including the Richfield Tower and Dana Villa, the railroad bridge, and the highway itself. The entrance to Doheny Beach was then on Pacific Coast Highway. (Courtesy Doheny State Beach.)

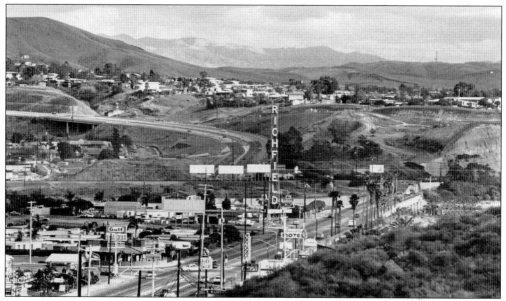

MIX OF THE 1960s. By the 1960s, advertising signs lined Dana Point's highway, this section located between Del Obispo Street and Doheny Park Road. One competitor (lower left) of the Richfield station was advertising gasoline at 33.9¢ a gallon. The 125-foot-high Richfield tower was dismantled in 1971. Development can be seen surrounding the freeway intersection on all levels. (Photograph by the author.)

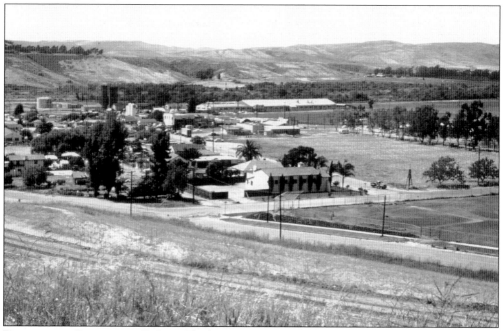

DOWNTOWN CAPISTRANO BEACH. The business section of 1960s Capistrano Beach along Doheny Park Road offered a mix of businesses, including Reeves rubber factory in the background. In the foreground is St. Edward's Catholic Church. The railroad water towers can be seen in the left background. One train engine exploded there while filling its boilers during that decade. (Courtesy Orange County Archives.)

DANA POINT PLAZA. The 1920s plans for Dana Point's town center designated a U-shaped street above the highway as La Plaza, "the marketplace, a town square." This 1970s scene saw South Coast Scenic Improvement leaders admiring the sailboat-decked sign. The flagpole that still stands behind it is the mast of a sailing ship that was wrecked on the rocks in pre-harbor days and salvaged by local citizens. (Photograph by the author.)

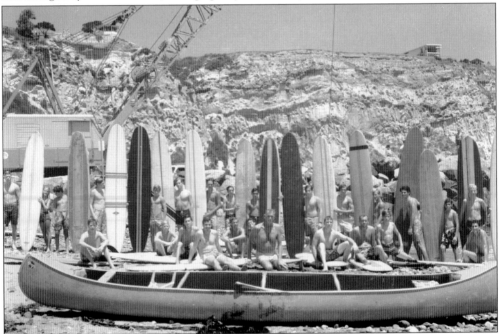

FUNERAL FOR KILLER DANA. Dana Cove, which had become a surfing legend in the 1950s, was closed to water sports in 1966 to facilitate the building of Dana Point Harbor. As a crane prepared to drop the first breakwater boulder, surfers surrounded legendary canoe surfer Ron Drummond of Capistrano Beach to pose at a funeral for Killer Dana.

Eight

NAUTICAL REBIRTH
DANA POINT HARBOR

We are dedicating more than a harbor; we are dedicating a facility for the enjoyment of all people,
a multi-purpose recreational facility offering educational, historical and scientific opportunities
unequaled elsewhere in projects of this type.

—Brig. Gen. F.A. Camm
U.S. Army Corps of Engineers, Dedication Day 1971

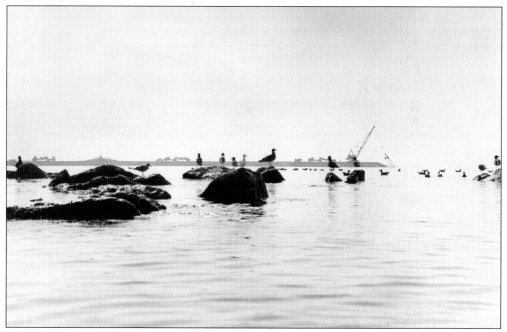

PREVIEW OF CHANGE, 1966. Sea birds that made their home in Dana Cove watch as harbor breakwater construction creates a growing stone wall between them and the open ocean. Synchronized heavy-duty trucks moved back and forth along the two jetties. At the end of each, a crane plucked and placed capstones, each weighing up to 20 tons, into place with precision. (Photograph by the author.)

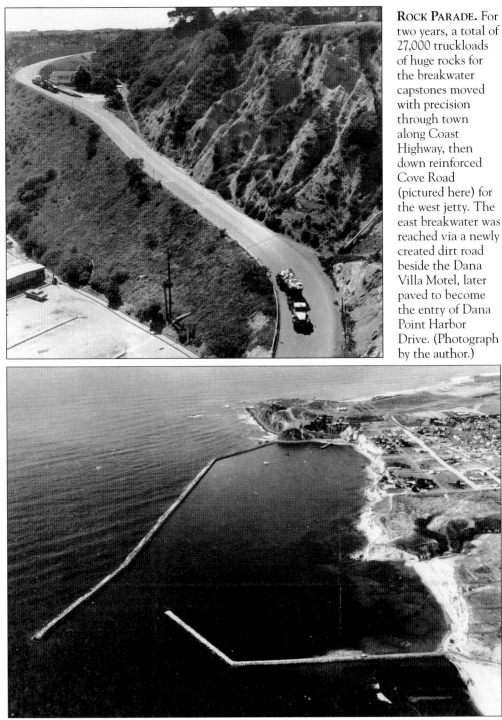

ROCK PARADE. For two years, a total of 27,000 truckloads of huge rocks for the breakwater capstones moved with precision through town along Coast Highway, then down reinforced Cove Road (pictured here) for the west jetty. The east breakwater was reached via a newly created dirt road beside the Dana Villa Motel, later paved to become the entry of Dana Point Harbor Drive. (Photograph by the author.)

BREAKWATERS DEFINE HARBOR, 1968. The new harbor would encompass both coves pictured here—Dana Cove at the top of the photograph and Fishermen's, seen beyond San Juan Point. The latter would be cut away and used as fill along the edge of the bluffs and to create a cofferdam. The 1920s promise of a "stillwater bay" had finally been realized.

WHOLE AREA TO CHANGE. A last look at San Juan Point, at center between the two breakwaters, is offered in 1968 before earthwork would begin. As Dana Point Harbor construction within the breakwaters was happening, so was major redevelopment of Doheny State Beach. Its main entrance would be diverted from the Pacific Coast Highway to the new road entering the harbor. (Courtesy Smetona Photo.)

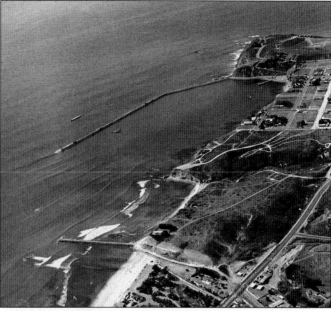

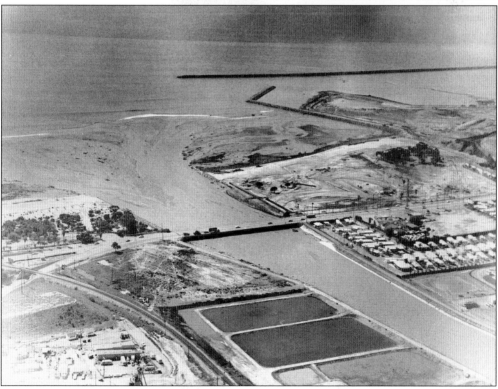

DIRTY WORK ALL AROUND. This February 1969 photograph reveals San Juan Creek full from winter storms, its accumulated silt flowing out to sea. The extensive buildup along Doheny Beach beside Dana Point Harbor's new breakwater eventually necessitated dredging. Restructuring of the Doheny campground north of the creek was also underway, as was interior "dirty work" within the harbor at top right. The former Dana Point Marina Mobile Home Estates is seen at lower right.

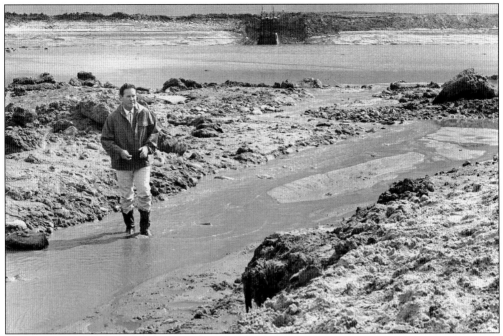

STANDING DEEP. An earthen cofferdam was constructed within the two breakwaters in order to give berthed boats a second protection from wave action. Surveying his "field office," resident engineer Jack Raines watches the sea bottom emerge as 4,000 gallons of water a minute are being pumped out by a two-story pump, at center back. (Photograph by the author.)

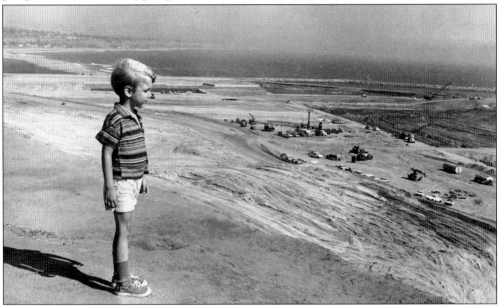

TOPSIDE VIEW OF FUTURE. Local youngster Blair Dana Walker gets his first engineering lesson watching the earthwork of harbor construction during 1969. Land construction vehicles maneuvered throughout the drained and graded areas. The launching ramp basin is visible behind Walker's head, while heavy equipment refines the landfill to shape roads, business pads, and parks. Beyond them is the empty East Basin. (Photograph by the author.)

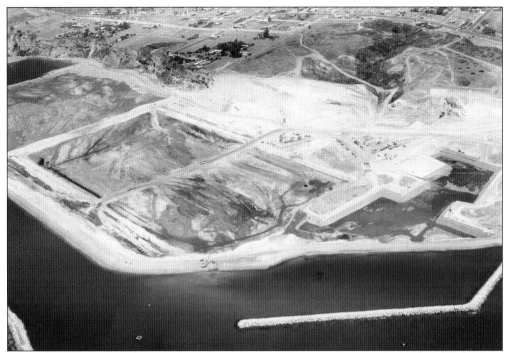

THREE BASINS DEVELOPED. The launching ramps, at far right, await the breaking of the cofferdam, enabling 50 million gallons of seawater to rush back in. The East Basin, at center, would be completed next, followed by the West Basin. Historic San Juan Point was already cut away (see background) and carried out to sea to form the landfill and the cofferdam. (Courtesy Geotronics.)

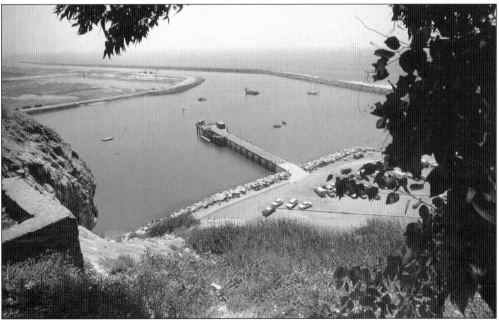

CHANGING VIEW. As groundwork continues within the cofferdam, as seen at far left, the fishing pier, resurrected and restored several times since the 1920s, continues to play its part within the harbor. Fishing can be enjoyed there without a license. (Photograph by the author.)

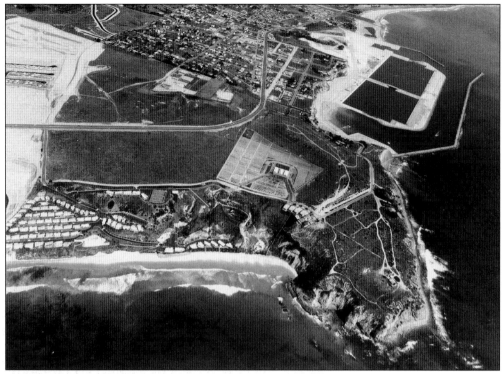

CONCRETE OUTLINES. By 1970, concrete revetment walls had been poured inside and outside the berthing basins. The bridge between them had been built. This aerial view also shows trails along the undeveloped headlands and the nursery of native plants maintained by the Sherman Foundation at the center. (Courtesy Geotronics.)

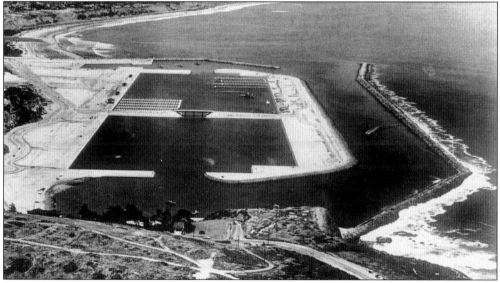

BOAT SLIPS BEGIN. One hundred slips on floating docks had to be ready each month for their new renters. Each month from May 1971 until March 1972, as soon as they were open, the berths were filled to capacity; there are close to 1,500 resident vessels in this East Basin. Eight boater support buildings and two shopping villages were also constructed.

EAST BASIN FULL HOUSE.
The harbor's East Basin
continued to have a waiting
list of hopeful renters.
The area above it was
being graded to create the
Lantern Bay development.
Here in October 1972,
new development was
extending the town in all
directions, including Street
of the Golden Lantern and
construction of Dana Hills
High School. (Courtesy
Ace Aerial.)

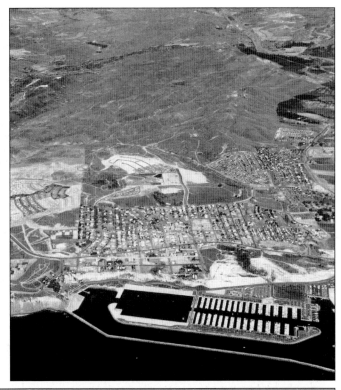

WEST BASIN FILLS. By 1976, the West Basin was constructed, its docks perpendicular to those in the East Basin. Exactly a decade after the first breakwater rocks had been dropped into place, the second berthing basin was dedicated. Its 1,000 slips were filled within months. Park areas at the harbor's west end were popular with landlubbers. (Photograph by the author.)

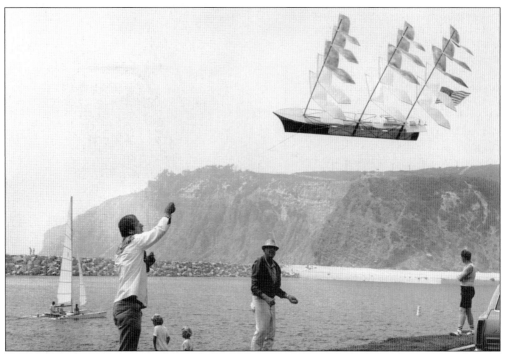

Nautical History Celebrated. A three-masted ship, the *Alert*, brought Richard Henry Dana into this anchorage on his second visit of 1835. Here it is flown as a specialty kite during a public event held in the namesake's memory. Dana's experiences made history in his classic book, *Two Years Before the Mast*. (Photograph by the author.)

Harbor Logo. The official seal of the harbor carries the silhouette of the brig *Pilgrim*. A full-sized re-creation of the ship that Dana crewed on his first visit here is docked in the harbor at the Ocean Institute. *Pilgrim's* two masts are square rigged. The entire ship is maintained by a devoted volunteer crew.

NAMESAKE RETURNS. The man who noted the dramatic setting of Dana Point, Richard Henry Dana, was awarded a permanent place to view its dramatic cliffs. In 1972, when the harbor was new, citizen donations funded a larger-than-life statue of Dana that stands on the island also named for him. He holds a copy of his journal of notes kept while on his voyage to California. (Photograph by the author.)

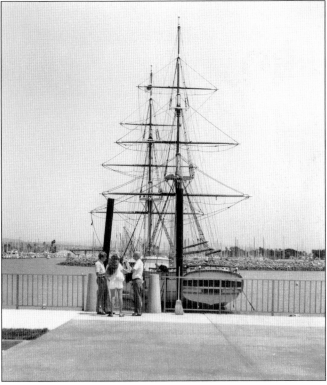

TALL SHIP PORT. Vintage sailing ships from the seven seas have visited Dana Point Harbor during its annual Tall Ship Festival and whenever they make a port call while passing by. Tall masts and yardarms, here on the re-created *Pilgrim*, have become a common sight in this city, though they always add a special nostalgic touch: in sailing by them, going aboard, or simply standing beside them. (Photograph by the author.)

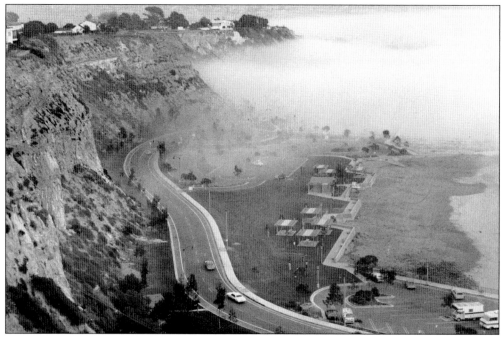

FOG FILTERS IN. Like a stage curtain drawing closed at the end of a fine performance, now and then the fog rolls into an actively used Dana Point Harbor. Visitors and boaters use the facility year-round, and the weather almost always accommodates their activities on land and sea. (Photograph by the author.)

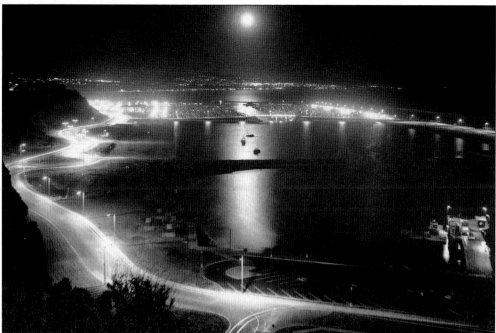

HARBOR LIGHTS. A full moon adds a romantic dimension to the harbor lights that shine throughout the marina areas, casting its reflection in a path through the center of this night scene. (Courtesy Smetona Photo.)

Nine

RESORT PORT CITY

We have an incredible site here in Dana Point. The wild ocean is on one side; the tranquil harbor is on the other, and the rugged cliffs form the backdrop. The inspiration for ongoing prime exploration is a constant challenge.

—Dr. Stanley Cummings
Dedication of Orange County Marine Institute, 1981

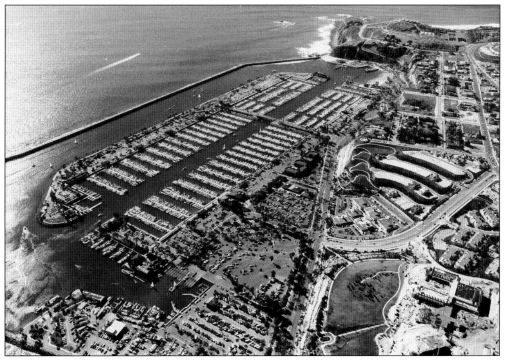

TWO-LEVEL RESORT PORT. This 1987 aerial view of Dana Point highlights the completed harbor and parks, with the Lantern Bay community underway and the Pavilion Center beside it. The headlands then remained an undeveloped mystery. In that year, the Dana Point Historical Society was founded with a goal of preserving the past as well as honoring current history. Incorporation of the city would follow in two years, unifying three communities. (Courtesy Lloyd de Mers.)

OCEAN INSTITUTE. In 1981, the then–Orange County Marine Institute moved into its permanent quarters in Dana Point Harbor. Since occupying these modest buildings, it has grown in scope and structure. Its location at the base of geologically significant Dana Point enhances its science teaching. At its back door is a protected marine preserve, and in its front yard are ships that enable its students to explore the sea itself. (Photograph by the author.)

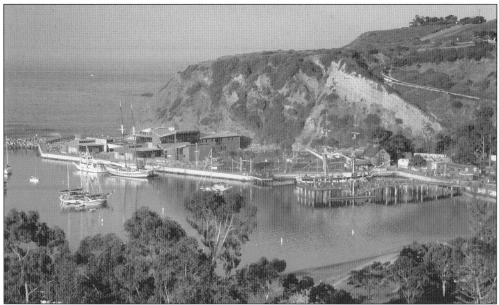

LAND AND SEA ASSETS. In 1999, this educational entity was renamed the Ocean Institute, a private non-profit attended by students from throughout California and beyond. The mission statement is "to inspire all generations, through education, to become responsible stewards of our oceans." In 2002, it moved into this more expansive education center. On land, students learn hands-on with interactive laboratories and exhibits. (Photograph by Cliff Wassmann.)

RV SEA EXPLORER. This fully equipped oceanographic research vessel offers educational cruises, including whalewatching, for students and the public. Since 1994, year-round classes have been conducted aboard the diesel-powered aluminum *Sea Explorer* with its custom oceanographic laboratory that provides students with a special opportunity for hands-on study of marine species they could never see on land or in aquaria. The Ocean Institute also has two tall sailing ships docked outside its state-of-the art complex. The *Spirit of Dana Point* takes older classes to sea for an introduction to serious sailing, while they also study marine life. The *Pilgrim* gives elementary school students the chance to learn the ropes of what sailing was like in the 1800s on overnight classes without leaving the harbor.

FIRST OF THE RESORTS. The Lantern Bay development of the 1980s included this 376-room Victorian-style hotel above Dana Point Harbor. It opened as the Dana Point Resort and later changed ownership to become the Laguna Cliffs Marriott Resort at Dana Point. It overlooks Lantern Bay Park with stairways connecting the upper city and the harbor. Highlights of the hotel include the Richard Henry Dana Ballroom, the Pacific Learning Center, and an on-site spa.

ST. REGIS RESORT. On 170 acres overlooking the coast is the 400-room St. Regis Monarch Beach Resort and Spa. Its Tuscan-style architecture carries a feeling of the Italian Riviera, and its grounds include the Monarch Beach Golf Links with an oceanfront green. Its guests enjoy a blend of comfort and top technology. Resort amenities of Dana Point headlands development are yet to come to join these top-rated luxury oases within Dana Point, the new resort port.

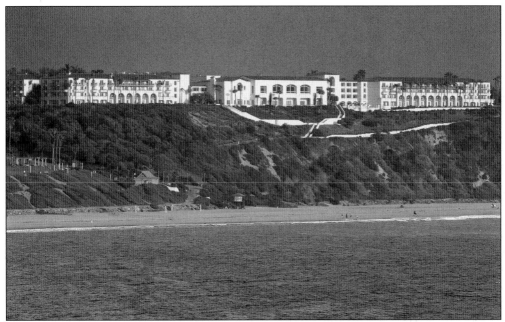

RITZ-CARLTON. Echoing the Spanish architecture of Dana Point's unfinished dream hotel of 1930 on a nearby bluff, this elegant resort has been a significant part of Dana Point social life since the 1980s, though its name is officially the Ritz-Carlton Laguna Niguel. This harkens back to pre-incorporation days, when Monarch Beach was considered part of Laguna Niguel. This 393-room Ritz-Carlton has been ranked consistently among the top resorts in the world.

DANA POINT YACHT CLUB. A group of foresighted boaters organized the Dana Point Yacht Club in 1952 without a clubhouse or a harbor. In the year following completion of the harbor, 1972, the expanded membership opened a clubhouse there. In 1998, they moved to this site on Dana Island. There the club began its annual Richard Henry Dana Charity Regatta, adding to the romance of local history. Dana West Yacht Club has also been active in the harbor since 1986.

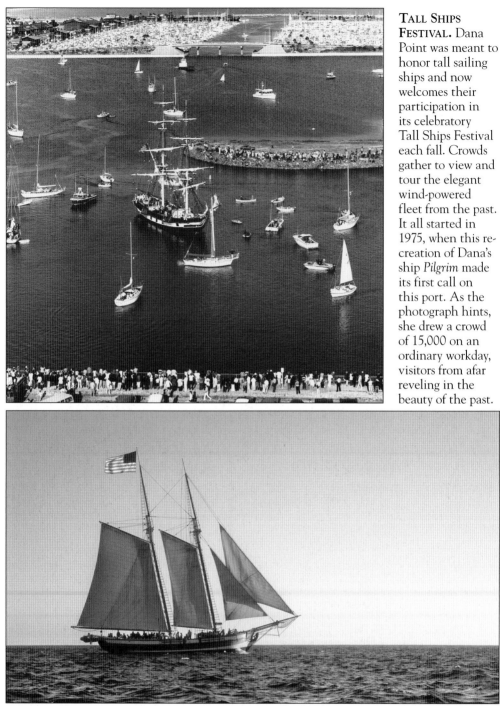

TALL SHIPS FESTIVAL. Dana Point was meant to honor tall sailing ships and now welcomes their participation in its celebratory Tall Ships Festival each fall. Crowds gather to view and tour the elegant wind-powered fleet from the past. It all started in 1975, when this re-creation of Dana's ship *Pilgrim* made its first call on this port. As the photograph hints, she drew a crowd of 15,000 on an ordinary workday, visitors from afar reveling in the beauty of the past.

SPIRIT OF DANA POINT. Enjoyment of tall ships is a year-round adventure for Dana Pointers, since two of the storied ones call it their home port. Joining *Pilgrim* at its Ocean Institute docks is the *Spirit of Dana Point*, a topsail schooner and replica of a speedy 1770s privateer. She is the institute's at-sea learning classroom for marine science and living history as well as a public cruise ship offering a variety of sails. (Photograph by Cliff Wassmann.)

LEARNING THE ROPES. In addition to teaching young students the ardors and glories of crewing a vintage rigged ship, the Ocean Institute extends this slice of living history to the devoted volunteer crew that maintains the ships, with headquarters in a New England–style sail loft beside the dock. *Pilgrim* sails only once a year, her 8,600 square feet of sails unfurled. Her two tall masts rise 110 feet in the air, scaled by experienced crews in the line of duty. (Photograph by the author.)

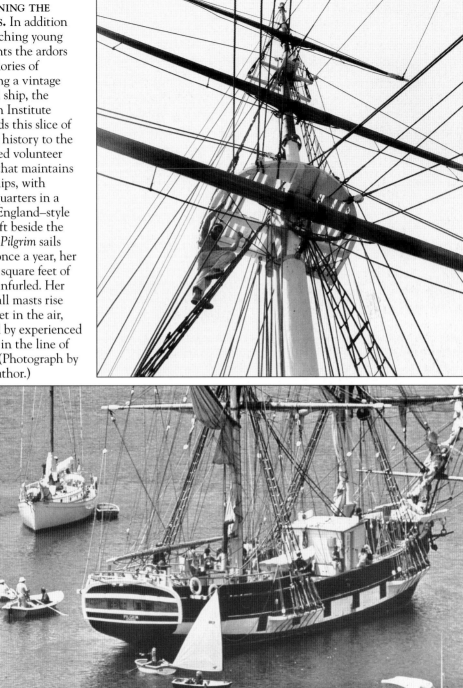

NEW ENGLAND REAPPEARS. While equipped with legally required engines, a stainless steel sink, and crew bunks for student overnights, this *Pilgrim* re-creation imparts a true feeling of being a player in maritime history. Elementary school students become crewmates, assigned to such duties as handling lines, raising sails, keeping watch, and gathering hides, as in the past. It is a rugged adventure, but one they never forget. (Photograph by the author.)

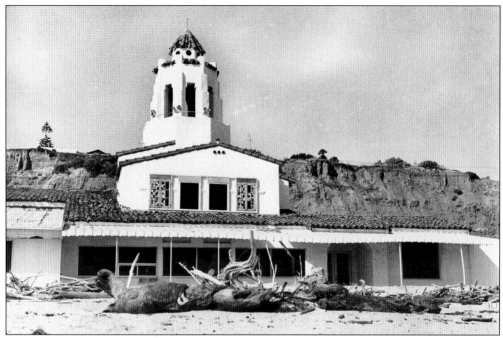

Some 1920s Landmarks Lost. The Capistrano Beach Club's strand suffered serious erosion, and driftwood from storms replaced the sand. After its final closing in 1966, it also suffered from vandals. A development company won approval to replace it with a 10-story hotel. Enraged residents filed suit. Nonetheless, the new owners razed the lovely landmark from its tower to its toes. The hotel to replace it was never built. (Photograph by the author.)

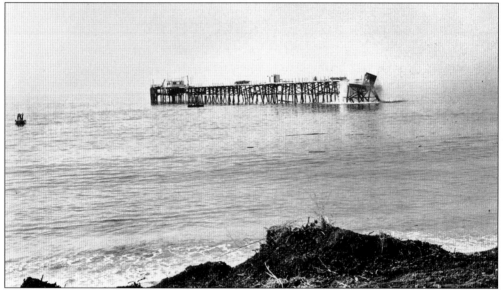

Capistrano Beach Fishing Pier. This living remnant of Ned Doheny's 1920s plan served fishermen and sportfishing boats for four more decades. Finally, storms in 1964 broke it from the land and left it shortchanged and irreparable. It had to be dynamited away, after flocks of pigeons living within it were rescued. The demolition team carefully carried them out alive in the empty explosives boxes.

DANA VILLA'S LAST CALL. While Dana Point was growing into a resort port, its first hotel was ailing. The Dana Villa Motel and Apartments advertised low rates for "family units," and its cocktail lounge advertised "dancing nitely." It still had a "large heated pool" and "low rates," but the handwriting was literally on the wall. (Photograph by the author.)

TENDER 1920s TIMBERS. There were vain attempts to resurrect the old Dana Villa, then to turn its grounds into a new version worthy of its location at the harbor's south entrance. Finally the city decided it should be demolished; it was in 2001. The large bare lot on the highway next to Doheny State Beach supports seasonal endeavors such as Christmas tree sales, with no final blueprint yet in sight. (Photograph by the author.)

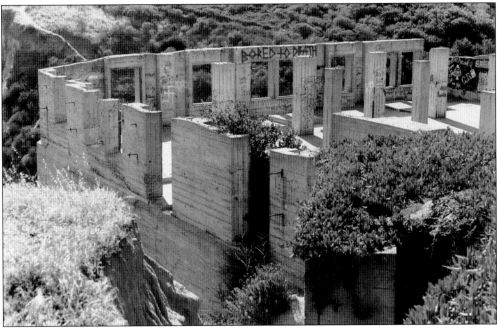

LINGERING GHOST HOTEL. Over the decades since its unfinished foundation was poured, the old Dana Inn watched the development of Dana Point Harbor and the city's resort amenities, realizing it had been destined to be one of them. Its framing gone, its windows closed, it dominated Dana Point's bluff-top silhouette. Cliff climbers and birds of prey found it an inviting rest point. Vandals made their unwelcome marks. (Photograph by the author.)

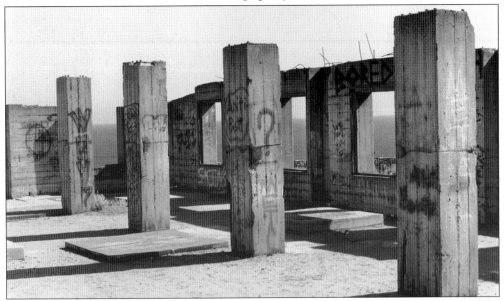

FATE: A QUESTION MARK. The sturdy concrete ruin seemed impervious to change—a mysterious Stonehenge adding curiosity to the site. Public pressure required its owner to demolish parts and mortar up others in the 1960s. A chain-link barbed-wire fence kept out the curious. Legends arose about weird wails and ghostly apparitions. A graffiti question mark was apropos. (Photograph by the author.)

114

ARCHES PRESERVED. When a developer did begin breaking up the ruin to build the Admiralty complex in the 1980s, the new Dana Point Historical Society stepped in to salvage a remnant. One row of original arches was preserved, now a focal point on a bluff-side trail between Streets of the Violet and Amber Lanterns, where traces of the 1920s stone path can still be seen. Here the *Pilgrim* and the headlands appear through one arch. (Photograph by the author.)

HIDE DROGHER STATUE. Permission to build on the hotel site included funding a piece of art. A statue of one of Dana's crewmates tossing a cowhide over the bluff, as in history, was designed. Liz Bamattre, historical society president, became the adoptive mother of the Hide Drogher, guiding details of its creation and installation. The Drogher also became the society's logo: a worker whose job was to deliver the goods to his crewmates, an Old West Indies term.

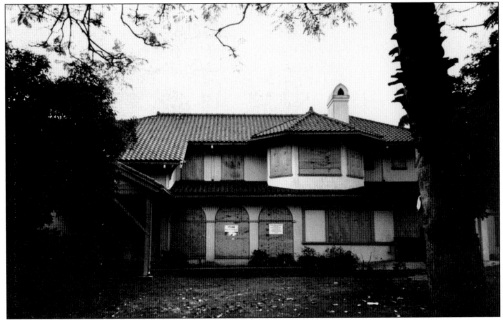

DOLPH HOUSE HIBERNATES. In 1953, when Dana Point's first residence was nearly 40, it earned a new role as an office for Capistrano by the Sea Hospital. Modern buildings were erected around it. This "hospital of tomorrow" had celebrities among its patients and became a university teaching hospital. After it closed in 1998, the buildings were vandalized. The Dolphin was boarded up, its future questionable. (Photograph by the author.)

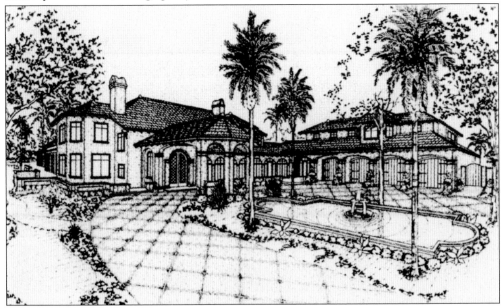

NEW LIFE FOR AN OLD HOUSE. In the new century, the property was acquired for construction of a group of select homes on the secluded hilltop. Thankfully, the Dolph House was not only saved, but was beautifully restored throughout and given state-of-the-art residential amenities after having been "the old building" in its hospital days. Now it shines as an elegant private residence again with a unique history.

DANA POINT HOME TOURS. In 2000, the Dana Point Historical Society initiated a new phase of its historical restoration commitment by inviting the public to tour significant Dana Point homes. Its overwhelming success has made the Home Tour an annual event, featuring residences including 1920s Woodruff (above) and Doheny (below) homes and 1960s models in Monarch Bay. In the process, the historical society has aroused interest and affection for buildings of the local past.

FIRING UP HISTORY. When the Stonehill Bridge was completed in 1992, the first vehicle over it was this 1965 Crown fire engine, the first state-of-the-art unit to serve the area. It spent its whole career at Station 29 in Capistrano Beach, acquired by the Dana Point Historical Society when it retired. Celebrating this dual role of history and civics are, from left to right, Doris Walker, historical society and Festival of Whales cofounder; Bill Bamattre, the mayor who drove the fire truck that day; and Carlos Olvera, then and now society president.

DANA'S FEATHERED FISHERMEN. Pelican watching is a special sport within Dana Point Harbor. Diving and soaring in search of fish, brown pelicans are the most historic of species along this coast, little changed since their prehistoric days and celebrating a triumphant return from endangerment. They hang out on the bait barge and breakwaters and greet each returning sportfishing boat, knowing what it has carried back to the dock. (Photograph by the author.)

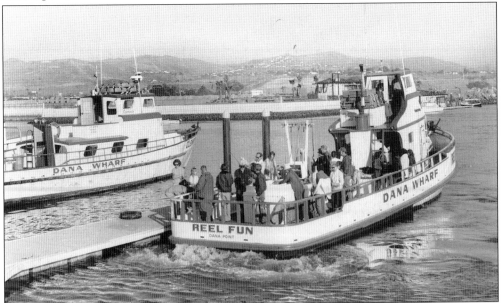

DANA WHARF SPORTFISHING. A resort port deserves a seasoned sportfishing fleet. Dana Point's fleet played a significant role in local life long before the city became a vacation destination. After years at San Clemente's municipal pier, Dana Wharf's operation moved into this harbor as it opened in 1971. Its vessels offer a range of fishing trips and whalewatching cruises. The ships are a highlight of the harbor's annual Christmas boat parade. (Photograph by the author.)

118

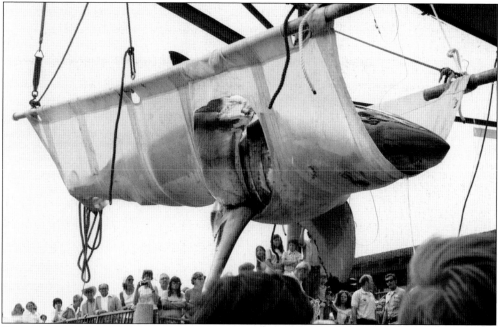

FANGS, THE GREAT WHITE SHARK. Suspended from a sling on the launching ramp crane, this 18-foot great white shark was an unusual catch by the Dana Point commercial fishing vessel *Comanche* in 1976. Landed alive after a five-hour fight, the two-ton fish was transported to Sea World San Diego, where she was exhibited. In the moving process, her jaws opened for the public that gathered, giving her the nickname "White Fangs." (Photograph by the author.)

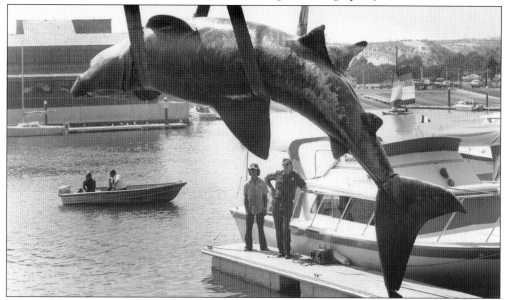

THE INCREDIBLE HULK. This five-ton newly dead basking shark was declared a navigational hazard when spotted floating just outside the harbor in 1978. The 24-foot fish was hoisted into the largest dump truck available, its tail dangling over the side as it rode to the county landfill. This second-largest fish species in the world is toothless, with filter-feeding gill-rakers instead of teeth. Its name around town became "Gills." (Photograph by the author.)

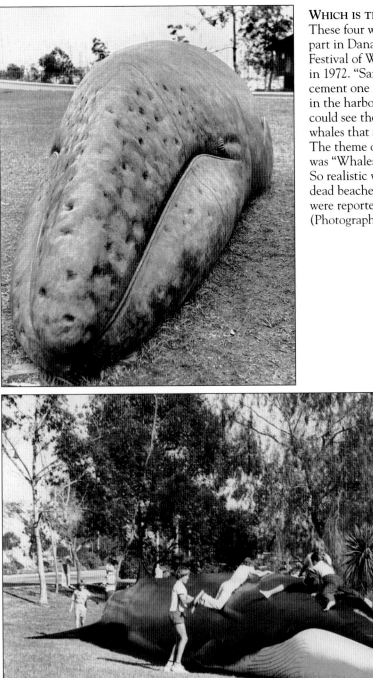

WHICH IS THE REAL WHALE?

These four whales all played a large part in Dana Point Harbor's annual Festival of Whales, which began in 1972. "Sandy," the 40-foot ferrocement one at left, was displayed in the harbor one year, so visitors could see the actual size of the gray whales that swim by each winter. The theme of the festival that year was "Whales on Land and Sea." So realistic was Sandy that several dead beached whale sightings were reported to the harbor patrol. (Photograph by the author.)

FIN WHALE. During another Festival of Whales, this 50-foot fin whale made of ferro-fiberglass came to rest in "Sandy's" spot. Its smooth surface was an immediate attraction for youngsters to climb on and learn. Like the gray whale, the fin whale is a toothless filter-feeder. "Pheena" stayed long enough to smother the grass underneath her, so a permanent topiary whale, "Herb," was planted there at Dana Point Harbor Drive and Island Way. (Photograph by the author.)

GRAY WHALE WITH BARNACLES. This is the head of a real gray whale, whose migration is celebrated as pods of its species visit the Dana Point coast each year. Their successful return from whaling days was brought to the state's attention by Festival of Whales devotees, earning it the honor of becoming California's official marine mammal. Barnacles attach themselves to these slow-swimming whales, filter-feeding along with their host. (Photograph by the author.)

"FLO," THE HUMPBACK WHALE. During one Festival of Whales, the enormous air-filled Flo joined visitors, floating along the children's parade route propelled by dozens of supporting hands. She fulfilled that year's theme: "Whales on Land, Sea, and Air." Humpback whales are sometimes seen feeding along this shore. Namesake Dana reported sighting finbacks and humpbacks, as well as the dolphins still so active in these waters. (Photograph by the author.)

HISTORY REPEATS ITSELF. While the Festival of Whales began in 1972, mention of Dana Point's association with this sea mammal was made in 1927, in the January 30 edition of the *Los Angeles Examiner*, as the early development of Dana Point was being announced. This caricature ties the name of the place and the three-masted ship *Alert*, the second vessel that brought namesake Dana here, with the visit of the whales.

KIDS AND WHALES. Children visiting the Dana Point Festival of Whales one year were invited to draw their vision of a whale on a real weather balloon filled with helium. The finished work of art was hoisted atop the buildings of Mariner's Village for all to see. Other special festival events of the past included air-to-sea-to-land demonstrations by the United States Navy's underwater demolition and parachute teams. (Photograph by the author.)

FILLING UP A WHALE. The local elementary school, R. H. Dana, one year marked the annual visit of gray whales by painting a full-sized outline of the celebrated marine mammal on their schoolyard. Then this class, as part of their study of whales, sat inside the outline; they needed to invite another class to join them to even begin to fill the vast space. (Photograph by the author.)

FIRST FESTIVAL PARADE. The Festival of Whales parade, now adult and motorized along Pacific Coast Highway, began in 1972 as a children's parade along the marina walkways. Grand marshals that year were a pair of lion cubs that paraded on a trailered boat, announcing that "The King of the Jungle Salutes the King of the Sea." The cubs were residents of Irvine's Lion Country Safari. Disney's Donald Duck was grand marshal in another year. (Photograph by the author.)

LANTERNS PRESERVED. Most of the lanterns that lit the streets of the original 1920s town disappeared during the lean 1930s. Some went to war as scrap metal in the 1940s. Fortunately 15 lanterns were saved and restored in the late 1980s to light La Plaza Park when it too was refurbished. The pictured tower on La Plaza reflects the New England Seacoast theme the 1980s Specific Plan required for commercial buildings. (Photograph by the author.)

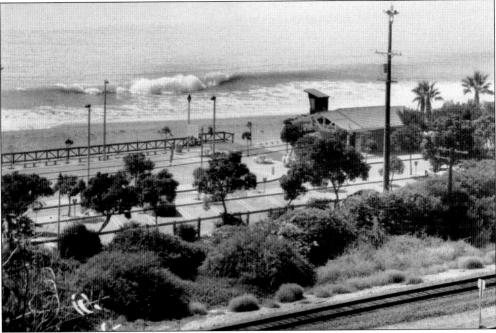

CAPISTRANO BEACH PARK. It once held the Doheny beach club, razed in the 1960s. Early palisades homeowners were deeded access to this strand, so fences around it were cut for entry to "Hole in the Fence Beach." The private-public issue was solved in 1980 when the County of Orange bought 1,500 feet and the state acquired a portion to expand adjacent Doheny State Beach. Under this park's sand lies the beach club's historic pool. (Photograph by the author.)

HARBOR TIME CAPSULE. Where Doheny State Beach meets the east jetty lies an enormous rock that was given a special role. It holds the Dana Point Harbor time capsule, filled with photographs and memorabilia by citizens and organizations as construction began. A beach barbecue is scheduled for the 50-year anniversary capsule opening ceremony on August 29, 2016. Tickets given out at the 1966 dedication will bring a free barbecue dinner "when presented by original owner" at that future date. (Photograph by the author.)

NEW TOWN CENTER. Dana Point's major civic project of the early 2000s is the redefining of Town Center, which starts at this split of Pacific Coast Highway and Del Prado. Significantly it lies between the city's two other major transformations of the decade: harbor refurbishing below and headlands development above. Town Center must be traffic, business, and pedestrian friendly while retaining touches of its 1920s origin. Past, present, and future meet at this intersection with Street of the Blue Lantern.

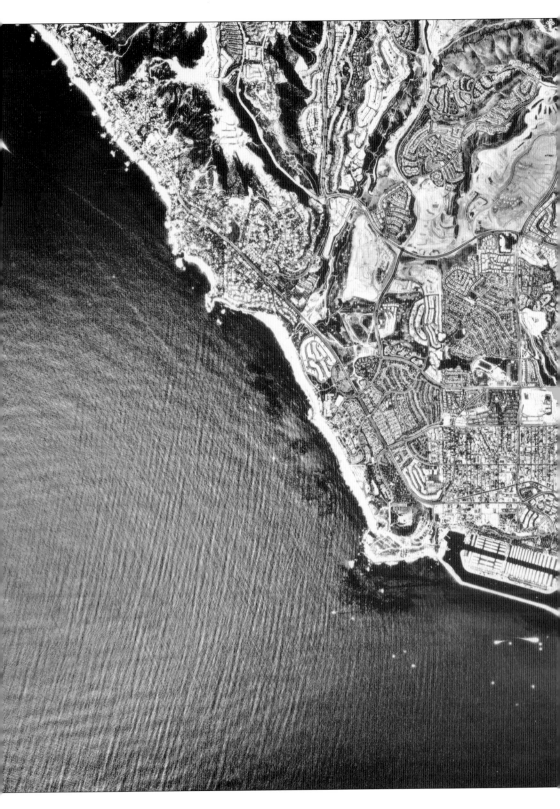

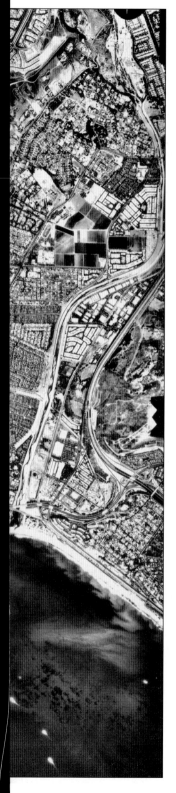

AERIAL PERSPECTIVE OF A CITY, 1989. Geography has been kind to Dana Point. Its varied vistas include panoramic views of the ocean, the mountains, the valley, and the canyons. While from an aerial photograph it may appear relatively level to anyone who has not had the pleasure of being there, the modern build-out has generally taken advantage of its varying elevations. Hilly terraces have become residential communities. Storied cliffs still surround the anchorage where its history began.

127

ACROSS AMERICA, PEOPLE ARE DISCOVERING SOMETHING WONDERFUL. *THEIR HERITAGE.*

Arcadia Publishing is the leading local history publisher in the United States. With more than 3,000 titles in print and hundreds of new titles released every year, Arcadia has extensive specialized experience chronicling the history of communities and celebrating America's hidden stories, bringing to life the people, places, and events from the past. To discover the history of other communities across the nation, please visit:

www.arcadiapublishing.com

Customized search tools allow you to find regional history books about the town where you grew up, the cities where your friends and family live, the town where your parents met, or even that retirement spot you've been dreaming about.